If You Don't Outdie Me

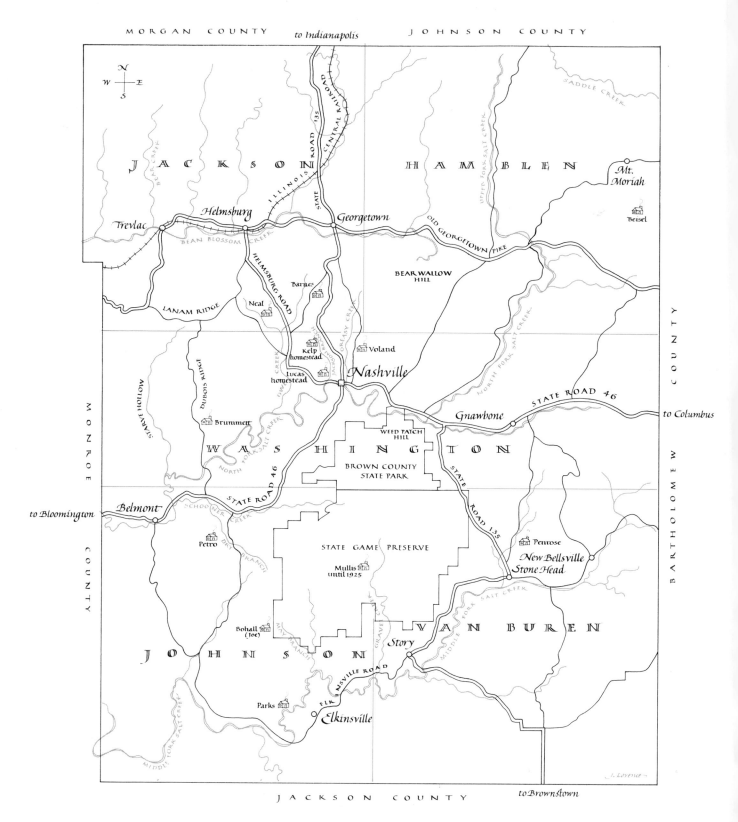

Brown County, Indiana
1930
with features mentioned in the text

"If You Don't Outdie Me

The Legacy of Brown County

❧ ❧ ❧

The Legacy of Brown County

❧ ❧ ❧

DILLON BUSTIN

INDIANA UNIVERSITY PRESS • BLOOMINGTON

FIRST MIDLAND BOOK EDITION 1982
Copyright © 1982 by Dillon Bustin

Manufactured in the United States of America

Library of Congress Cataloging in Publication Data
Bustin, Dillon.
 If you don't outdie me.

 1. Brown County (Ind.)—Social life and customs.
2. Brown County (Ind.)—Biography. 3. Hohenberger,
Frank Michael, 1876– . 4. Photography, Artistic.
I. Hohenberger, Frank Michael, 1876– . II. Title.
F532.B76B87 977.2'25304 82-47784
ISBN 0-253-13916-3 AACR2
ISBN 0-253-20305-8 (pbk.)
1 2 3 4 5 86 85 84 83 82

Contents

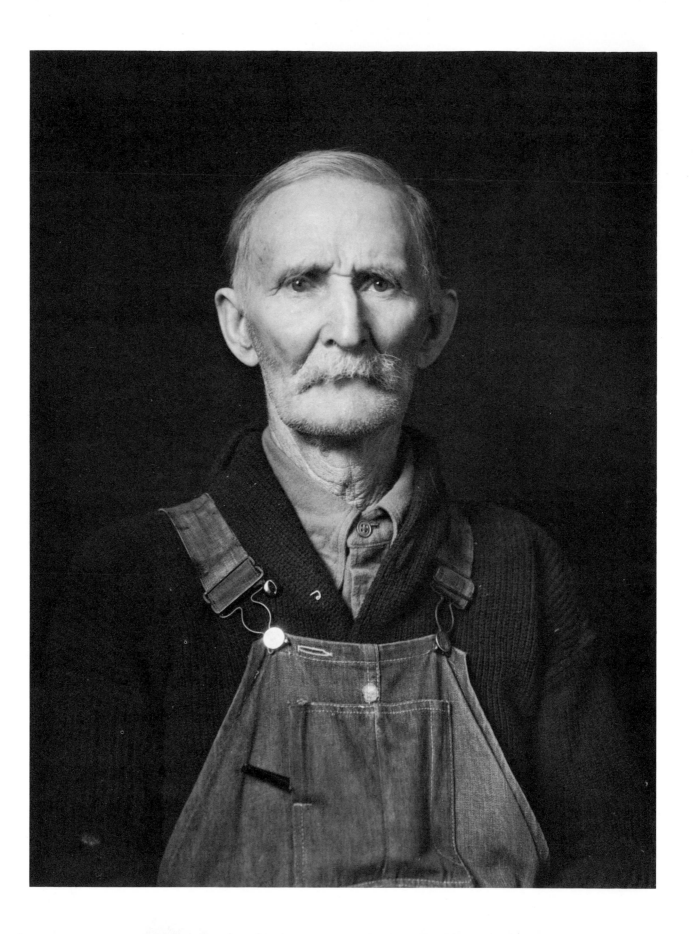

PREFACE

FOR AS LONG as there have been urban civilizations based on rural labor, there have been pretentious city people making fun of country people. And for almost as long, there have been disillusioned city people praising country people, even pretending to be country people. There is a certain prejudice in assuming that rural workers live lives of coarse, dull-witted drudgery; there is an equal injustice in assuming that they live lives of sublime simplicity. What is in the minds and hearts of serfs? of peasants? of plain folk? Are they more or less virtuous than their sophisticated critics? For centuries the debate has been sustained by uninformed attitudes and contrary generalizations. Only in the recent past has anyone with social advantages tried to hunker down with a hillbilly and listen carefully to his or her story.

In Brown County, Indiana, during the 1920s, the local inhabitants found themselves caught up in the old controversy—pitied or scorned by the Indianapolis civic elite, but idealized by a coterie of resident landscape and portrait painters. In the years following the First World War, these artists managed to convince thousands of motoring tourists that there was something mysterious and lovely not only about the Brown County scenery but also about the poor dirt farmers and their families who subsisted in primitive bliss along Greasy Creek, or deep in Starve Hollow, or high on Weed Patch Hill. Most of the members of the artists' colony disdained to get too close to their picturesque human subjects or to become personally acquainted with them. A few of the artists, especially Ada Shulz, Will Vawter, and Carl Graf, had the humility to live with their new neighbors. Yet only one outsider, the photographer and journalist Frank Hohenberger, thoroughly interpreted Brown County society.

When Hohenberger moved from Indianapolis to Brown County in 1917, he intended to make his living as a nature photographer. Like the other artists working in the county, he was an adherent of romantic pastoralism, and so his vision of nature could include cultural artifacts if they evoked the past. But within a few years Hohenberger began to go beyond split rail fences, fodder shocks, and log cabins; he began to promote an interest in the "natives" themselves, as entertaining characters. Beginning in 1923 he prepared a Sunday column for the *Indianapolis Star*, entitled "From Down in the Hills O' Brown County." In these columns he offered some of his finest photographs as well as written accounts of everyday life in and around Nashville, the county seat. Hohenberger realized that there was good money to be made by supplying pictures and anecdotes about the strange, unlettered folk who were supposed to

vii

inhabit Brown County. Nevertheless, he developed a penetrating curiosity regarding community life and an unusual willingness to listen to the men and women he met. As he wrote in a notebook entry for March 20, 1918 (referring to his artist friend Adolf Shulz):

Shulz says something like Holy Roller meetings are necessary—people must have some place to "cut loose." Tragedies in the valleys. Talking with the people reveals the mysteries.

Hohenberger never did learn to cut loose, but he did attend Holy Roller meetings, courtroom trials, high school theatricals, mule auctions, fox hunts, and square dances. His most significant work was done between 1920 and 1930, while Nashville was undergoing a sudden and profound modernization. During this decade Hohenberger stored away thousands of photographic negatives and hundreds of pages of typewritten observations. He revealed many small mysteries for himself, and for himself alone. His efforts to comprehend the local scene went far beyond the interests of the general public, and much of his material was not published during his lifetime. Indeed, his insights would not have been accepted by his readers in Indianapolis, for they contradicted popular opinion about Brown County.

This book is an introduction to some twenty individuals whom Hohenberger photographed and interviewed. In each section I have included, as full-page illustrations, one or two art prints from large-format negatives. I have also included many smaller, casual snapshots that when taken had no commercial value. I have not drawn from the newspaper columns, in which the Brown County folks tend to be portrayed with a condescending and artificial quaintness. Instead, each section contains excerpts from Hohenberger's diary notes, in which he recorded his impressions in an informal but less affected manner. These excerpts have been mildly emended for clarity and conciseness.

Perhaps because Hohenberger had come to Brown County in search of the past, he felt a special empathy for the elderly residents whose way of life was being replaced. Although he published the comic and nostalgic aspects of their appearance, he was aware of the tragic and forlorn aspects of their situation. He was their witness as they tried to protect their goods from youngsters who did not value the old things and from outsiders who valued them in a superficial way.

In 1929 Hohenberger's landlady, Allie Ferguson, saw a display of quilts and antique furniture belonging to Mary Barnes, a lifelong friend who had been designated queen of a festival to promote tourism. "I'll want that if you don't outdie me," Allie told Mary. It was just like Allie Ferguson to turn the matter of dying into a contest, and just like Mary Barnes to win. As it happened, Mary lived longer than Allie, yet both were losing a race with the future. The older

generation understood that newcomers were taking possession of Brown County and that the entire landscape was being remodeled to satisfy new needs. Those old folks could not understand why they were seen as comic-strip characters, but they lived out their days with inward dignity and self-assurance.

I offer this selection from Frank Hohenberger's work with the hope that his images, once able to speak for themselves, may be more fully revealed and appreciated.

D.B.

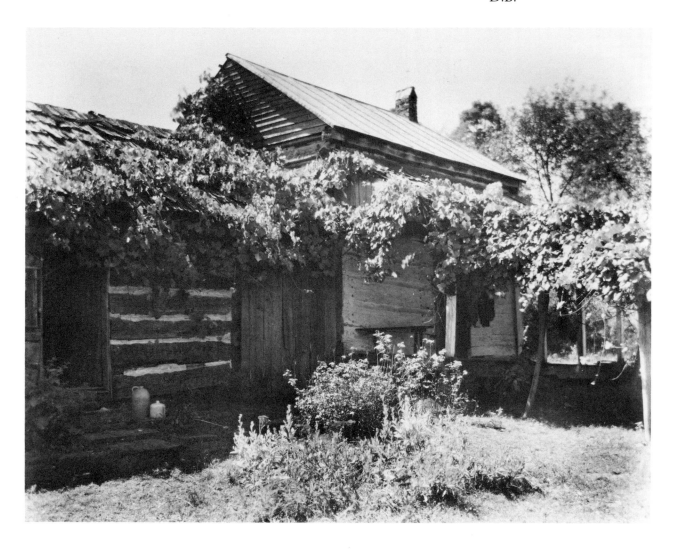

ACKNOWLEDGMENTS

THE BEST INTRODUCTION to the life and work of Frank Hohenberger may be found in a series of three articles prepared by Lorna Lutes Sylvester for the *Indiana Magazine of History* in 1975 and 1976. These articles were the first published glimpses into the Hohenberger Collection at the Indiana University Lilly Library.

I began to work my way through the 8,000 negatives in the collection and to correlate faces with names in Hohenberger's indexes and notes in 1978. The original survey was supported by a grant from the Indiana Arts Commission, which was administered for me by the Indiana University Foundation. I would like to commend Saundra Taylor, the Lilly Library's Curator of Manuscripts, and her staff for their excellent help. My work was greatly aided by two research assistants: James Chiplis, provided by the Lilly Library, and Gale Myles, provided by the Indiana University Folklore Institute.

The first result of this project was a photographic exhibition entitled "Tools of the Trade: Fine Artists and Folk Craftsmen in Brown County, 1920–1930," which has toured Indiana for the past two years under the auspices of the Indianapolis Museum of Art. I am happy to acknowledge that the enlargements and labels from "Tools of the Trade" have been acquired by the Psi Iota Xi Sorority of Nashville, so that they may be displayed permanently in Brown County.

For their expert care in reproducing Hohenberger's negatives and prints for me in the research phase, in production of the traveling exhibit and in preparation of this manuscript I am indebted to Beverly Kelly and her staff at the Indiana University Photo Lab. It has been a pleasure to learn from them about the technical aspects of historical photographs.

I have benefited from long talks with descendants and acquaintances of the people depicted in these pages. To have directly included their insights and opinions would have made this a very different kind of book. The issues that aroused such emotion during the 1920s are not forgotten, nor are they resolved, today. My curiosity about old records has been often indulged by the staffs of the Brown County Auditor's Office and Clerk's Office, as well as by the staff of the *Brown County Democrat.* I have enjoyed helpful conversations with Dorothy Bailey and Kenneth and Helen Reeve of the Brown County Historical Society, and with Jim Eagelman, Naturalist at Brown County State Park.

In analyzing the cultural significance of Hohenberger's diaries and photographs I have been especially influenced by John McDowell, on the faculty of the Indiana University Folklore Department, and by Michael Herzfeld of the Research Center for Semiotic Studies. I would like to thank David Nordloh of the Indiana University English Department for advice regarding the textual editing of Hohenberger's writings.

Finally, I express my gratitude to my wife, Martha, for understanding my absence during many late nights whiled away with Aunt Molly Lucas, Sam Parks, Alex Mullis, and Grandma Barnes in the Brown County of 60 years ago.

D.B.

Ed Voland's farm on Greasy Creek, October 23, 1926.

Geosophy is the study of geographical knowledge from any or all points of view. It deals with the nature and expression of geographical knowledge both past and present. It covers the geographical ideas, both true and false, of all manner of people—not only geographers, but farmers and fishermen, business executives and poets, novelists and painters, Bedouins and Hottentots—and for this reason it necessarily has to do in large degree with subjective conceptions.

JOHN KIRTLAND WRIGHT,
from *"Terrae Incognitae:* The Place
of the Imagination in Geography,"
*Annals of the Association of
American Geographers,* 1947

If You Don't Outdie Me

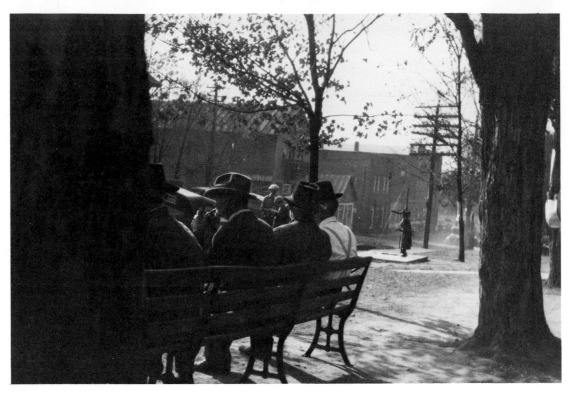

Looking past the Liars' Bench to the town pump and beyond, down Main Street west toward Helmsburg. October 26, 1924.

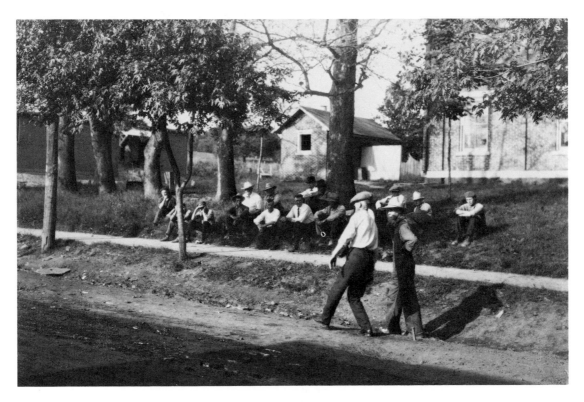

A horseshoe game in progress, June 14, 1924. Notable are artist Will Vawter, fifth from left with white shirt and hat; Postmaster Fletch Poling, in center with white shirt and dark tie; and barber's helper Lon Kennedy (soon to be arrested for moonshining), second from right in white hat, reclining. The man pitching the shoe is Herschel Mobley; the youth playing against him is Tom Hutchinson.

Prologue on the Liars' Bench

IMAGINE NASHVILLE, INDIANA, at dawn on Thursday, October 31, 1929. Around the county courthouse the trees quiver in the cool gusting air. The old locusts, and the young maples planted to take their place, are nearly bare of leaves. The sun appears through broken clouds above the hills to the east, spreading light down Main Street as a Studebaker farm truck turns in from Greasy Creek Road. The driver parks at a hitching rail in the jail lot and walks across the alley to a bench in the courthouse yard. He brushes away some leaves and wipes at the dew with his hand before sitting down at the end that is propped against a tree trunk. He reaches into his overalls for a pocketknife and commences to scrape the mud from his boots. The innkeeper emerges from a hotel across the street and strolls over to join the farmer. He has his weekly copy of the *Brown County Democrat*, which he spreads on the seat before sitting down. A third man comes walking in from a side street, carrying his dinner bucket and a set of horseshoes.

Soon there are enough men present for a game of horseshoes on the well-worn courts along the western edge of the yard. They play three matches before the landlady at the hotel rings for breakfast, and another four before the post office opens for the morning mail call. Some players leave for home after checking their mailboxes, but they are replaced by others, including the Postmaster, a few county officials, the proprietor of the general store, the druggist, the barber, the blacksmith, a carpenter, a stone mason, and many more farmers and common laborers.

All day long the horseshoe games continue. The men rotate between playing and commenting from the sidelines. Some just rest on the nearby bench. Occasionally the Clerk, or the Recorder, or the Prosecuting Attorney is called into the courthouse to attend to some paperwork. Customers come looking for a merchant or barber to ask that he open his shop. Occasionally a housewife fetches her husband home to do a chore. Several times tourists stop to gawk at the crowd around the bench and to take snapshots of the scene. But nothing can interrupt the playing, or the accompanying banter, except a sudden shower of rain in the late afternoon.

Toward dusk the wind shifts to the north, and the clouds begin to lift. Someone predicts that it will turn clear and freezing cold during the night, and that they might have to wear gloves when they pitch horseshoes tomorrow. Another man repeats the half-serious joke that they should build a glass enclosure around the bench and install a stove so that their gatherings may continue regardless of the weather. The last game of the day is played by the light of automobile

head lamps, and then the group disperses, amid friendly threats of Halloween pranks.

A routine weekday in Nashville, a little town with a big—and complex—reputation. Some outsiders condemn the place for its lazy, backward ways, while others extol it for its easy-going indifference to the modern world. The truth of the matter, now as then, is that neither opinion is fair. But outsiders will believe what they need to believe. Once a community is labeled as entirely graceful, or disgraceful, it becomes difficult for outsiders to recognize its actual inner life. On this particular Halloween, in 1929, real mischief is at hand, for some time after midnight a small mob of women in disguise converge on the square, drag the men's bench out into the main intersection, and bash it to pieces with hatchets and sledgehammers.

That bench had been publicized throughout the United States as the Liars' Bench; it was a symbol, and the destruction of it was an expressive act. Sitting on the bench meant something to the men who made it a habit; it suggested something else to the tourists who came to see them sitting there; it was taken a different way by the women who were exasperated and embarrassed by their husbands' pastime. To interpret the meanings attached to the innocent object requires a brief review of the history of Nashville and Brown County, and also a review of the relationship between Brown County and the rest of the world. By October 31, 1929, the stock market in New York City had been crashing for a week, but the Great Crash caused no drastic changes in Nashville. Brown County had never recovered from the nationwide financial reversals of the 1870s and had been in a severe depression for fifty years. Most public acts of outrage are inspired by issues of economics or honor; the destruction of the bench involved both, but the anger demonstrated by the housewives of Nashville had its origins in the hardships and indignities of a lifetime.

Economically, Brown County has always been a dubious proposition. It was formed in 1836 from the more rugged, inaccessible areas of Monroe, Jackson, and Bartholomew counties, nearly twenty years after the establishment of these original counties. Ordinarily, settlers holding lands taken for a county seat were reimbursed for their property. In Monroe County, for example, the Locating Commissioners paid $2,100 to two individuals for 310 acres to create Bloomington in 1818. In the new Brown County of 1836, the Locating Commissioners received a total free donation of 50 acres from seven landholders, who offered $150 in cash as an inducement to create Jacksonburg, later renamed Nashville. The local settlers also donated additional lands for revenue and even the furniture for the first courthouse.[1]

Typical of the progressive pioneers who aided in the formation of Brown County was Banner Brummett. He and his brothers, George and James, were included in the Monroe County census of 1820, having moved there from Vir-

ginia by way of Tennessee. Around 1835 Banner resettled on Salt Creek at the future site of Nashville, and the portion of his farm that he donated the following year became the courthouse square. He co-signed a note for cash offered to the Locating Commissioners and also gave twenty more acres for the benefit of the town. Appointed the County Agent, he let contracts for the building of a log courthouse and a log jail. At the same time he supervised the platting of the town and the sale of lots. Most of the lots in Nashville were auctioned off on credit, a plan that suffered after a deflationary bank scare and new federal currency policies in 1837. By the spring of 1838 Banner Brummett reported to the County Commissioners that only $260.31 had been collected in cash. County expenses until that time had been $246.48. These figures were very small compared to the financial activity of the adjacent county governments.

The first obstacle to the development of Brown County was the difficulty of access. Other hilly counties in southern Indiana had at least a navigable river to aid transportation, but Salt Creek could accommodate a downstream flatboat only when it was in flood. Brown County was bypassed by all the early state highway, canal, and railroad projects. In the outlying townships of Brown County the initial settlement process lasted into the 1850s and 1860s, and for decades the population density lagged behind the averages of the surrounding counties.

Local business and civic leaders realized that transportation was a key to growth. In 1863 the county invested in a proposed railway between Bloomington and Columbus. In 1869 the voters favored a special tax to create a fund for donation to another railroad company. In 1874 the county pledged $22,750 to a railroad projected to run from Indianapolis to Evansville. None of these railroads were built, and throughout the nineteenth century travel was limited to a partially gravelled highway running north forty miles to Indianapolis, and to dirt roads running east twenty miles to Columbus and west twenty miles to Bloomington.

Despite their uncertain prospects, the residents of Nashville faced the future with optimism, and for a time the town enjoyed a modest prosperity as a local farm service center. Nashville was incorporated in 1872. The brick courthouse, which had been built in 1854, burned to the ground in 1873, but was soon rebuilt. The original log jail was replaced by a similar structure in 1879. By 1880 the population of the town itself was about 350. The countryside around supported five general stores, four groceries, four drugstores, a hardware store, a furniture store, two hotels, and a weekly newspaper. Nashville was home to about five dozen tradesmen and craftsmen and to two dozen professionals such as doctors, lawyers, and teachers. In addition to the common schools there were a private academy, a public chautauqua, and plans for a county seminary.

Unfortunately, after the 1870s the community life of Nashville began to falter. The seminary was never built, and the academy and chautauqua soon

The Old Log Jail, photographed from the Courthouse. This archaic structure got a lot of attention in Indianapolis and Chicago newspapers as early as the 1890s.

The Brown County Courthouse, October 1920. The Greek Revival design reflects its origins in the 1850s. After a fire in 1873, it was rebuilt along existing lines even though fashionable styles for new courthouses were then Neo-Gothic and Italianate. These two simple buildings, seats of government within a block of a cornfield, were like a dream to many city dwellers.

closed. The specialty stores and hotels had trouble staying in business, and all but two or three doctors and lawyers left town. The underlying problem was a lack of valuable resources. This lack of raw material proved to be a far greater obstacle to the development of Brown County than the hills themselves. As industrialization transformed Indiana in the second half of the nineteenth century, the residents of the county found they had little to offer the larger economy—no coal, oil, or natural gas; no mineral ores; no commercial clay, gravel, or building stone deposits. There was plenty of timber, but no feasible way to get it to distant urban markets. There was an excess labor pool, but not enough capital to initiate manufacturing of any kind. The hill farmers could not compete with the farmers in the flatter, more fertile areas to the north and east, where agriculture was rapidly being mechanized. Even if they gained easy access to regional markets, after 40 crops of corn their topsoil was critically depleted and eroded anyway.

These conditions made Brown County vulnerable to national monetary fluctuations, and the Wall Street Panic of 1873 proved disastrous. By the end of the decade, for the first time, farms in the less fortunate neighborhoods were being lost because of unpaid taxes and forfeited mortgages.

Hohenberger recorded in his notes for January 1924:

> In 1878 there were about 500 pieces of listed property delinquent. Allie Ferguson says that her husband was collector of taxes when Henry Miller was treasurer. He was in danger, lots of times. Would bring in horses and cows and put them in poor farm grounds as payment for taxes. The rule was to ask the collector what his fee was and then they would pay that and let the taxes pile up some more.

Federal census statistics indicate that the population of the county peaked during the 1880s at around 10,000 persons. Then began an accelerating stream of out-migration, and by 1930 the population had been reduced by half.[2]

Brown County's unfavorable commercial position also affected its image in popular opinion. As long as the economy of Indiana had been based on small-scale mixed farming, the county could keep up despite its disadvantages. But when industrialization changed the public's expectations, Brown County was suddenly poor. As it could not afford prestigious improvements it came to be considered a backward place, the home of coarse, shiftless simpletons. According to Social Darwinism, a dominant ideology of the time, hard luck was easily interpreted as laziness, and Brown County was used as a negative example by the business and political elite in Indianapolis, inspiring countless jokes, sermons, and editorials. By the turn of the century community leaders in Nashville were aware that their town was subject to ridicule. They were especially stung by the criticisms because they were eager to be as progressive as possible, but

were trying to maintain roads, schools, and other services with a diminishing tax base.

At this time Nashville was challenged for prominence by Georgetown (now Bean Blossom) and Helmsburg, two towns in the northern part of the county that were nearer to the commercial mainstream. Flecks of gold in creeks running through a nearby glacial moraine provided the raw material for an eyeglass frame factory in Georgetown. In addition, this town was the teamster depot for farm produce from the Hamblen Township bottomlands, the best growing fields in the county. But Helmsburg threatened to bankrupt both Georgetown and Nashville when it managed to attract the new Indianapolis Southern railroad line in 1902.

This line, completed from Indianapolis through Helmsburg to Bloomington by 1905, caused intense embarrassment in Nashville. Over the years several rationalizations were proposed (by outsiders) to explain why the county seat had declined to raise the necessary investment—the people were afraid that the trains would bring hobos, that flying cinders might set their barns on fire, that the whistle might scare horses and children. These excuses were consistent with the rustic yokel image, but the truth is that railroad companies had been aggressively courted by Nashville businessmen for two generations. By the time a realistic proposal was made by the railroad promoters, the advance money was simply not available. The Nashville economy had been declining for twenty years, several merchants had failed, and none of those still in business had the cash to risk.

The lack of a railroad confirmed Nashville's reputation as a town lost in the past and helped to attract a new type of curiosity seeker. As early as 1870 William McKendree Snyder, an aspiring artist working at his brother's photography studio in Columbus, made sketching trips into Brown County. In the 1890s a hiking trek to Nashville became a popular excursion for college students from Bloomington and amateur artists from Indianapolis. Reports by these would-be vagabonds incited newspaper reporters to make the same trip, and soon sensational travelogue pieces stressing primeval forests, quaint log cabins, and shaggy mountaineers were appearing in newspapers throughout the Midwest.

In the first decade of the twentieth century Brown County was established as an object of fascination by those who found industrial capitalism disturbing or distasteful. James Whitcomb Riley, who had a mass following for his nostalgia set to verse, sent his editor, Marcus Dickey, and his illustrator, Will Vawter, to Brown County to make drawings to include in his collections of poetry. (Both Dickey and Vawter soon returned to settle in Brown County.) Kin Hubbard, a cartoonist for the *Indianapolis News*, located his imaginary town of Bloom Center in Brown County. His main persona, a loitering critic of society named Abe Martin, was a caricature of a poor farmer. This wise fool proved to be quite

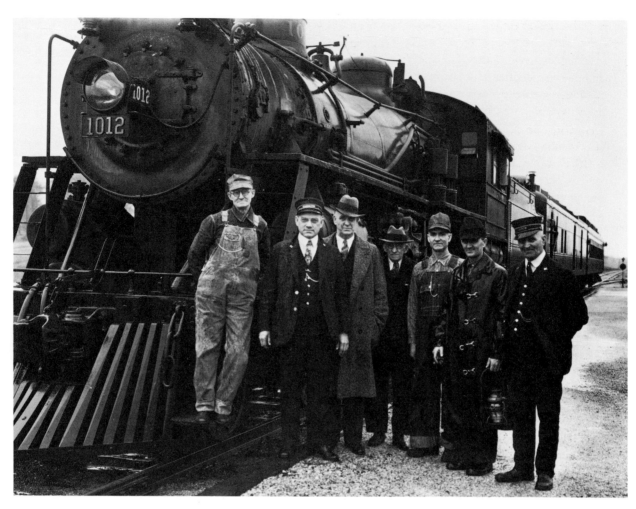

The Indianapolis Southern line was eventually
acquired by the Illinois Central Railroad. This
train crew, with Postmaster Fletch Poling (third
from left), was photographed at the Helmsburg
station in January 1932.

popular in Indianapolis, and his daily sayings were soon syndicated throughout the United States. Hubbard's series was deeply resented in Nashville, however, where it was hard to understand that the new publicity was not meant to be unkind.

Kind or unkind, the attention fixed on the rustic character of the county was a persistent annoyance to its leading citizens. Perhaps no one in Nashville was more sensitive to all this "bad press" than Alonzo Allison, the publisher of the *Brown County Democrat*. He had the task of making editorial rejoinders to the county's critics, as in this eloquent piece of sarcasm, attributed to "Seth" in the issue of July 20, 1905:

> The Indianapolis News of the 15th instant gives an announcement that sounds good to us. One of the State's most noted men has sworn by the great horn-spoon that he will never give, aid or assist another foreign mission of any kind, or place, but all the surplus change coming his way shall go to civilize poor old Brown county. Now, we ask that more men like him come to the front and assist in this charitable work. In this poor old country that God forgot, in the red brush, hazel and sassafras, where the woodchucks chuck and the chigres chig, and the mournful cry of the whip-poor-will away off somewhere makes the whole thing appear to be a vast burying ground, where the sun in the Heavens shines upon us only for about fifteen minutes at noon-time, and the cry of the wolf rings out around the tops of the hills all night long, giving the city-bred Abe Martin, who moved here last winter, a chill that will finally destroy his great oratorical ability; is it any wonder we are a neglected trodden race? Now, dear Missionary, come down and saw off our horns and make us your everlasting subjects. Teach us, Oh, big man, from whence we cometh, for some time an electric car is going to whiz through here and destroy us all, and then we shall not even know whither we goeth. This is an earnest, heartrending cry from the wilderness that will surely tug upon the heart of civilization with a mighty force. Come, Oh! come down into Macedonia and save us!

Yet sometimes wit seemed not enough to Lon Allison. Two months later, in September 1905, the *Bloomington Star* reported that the state legislature would consider abolishing Brown County and redistributing its territory among the surrounding counties. The *Star* article asserted that "Nashville the county seat of Brown, is not even an incorporated town, and no energy or enterprise is manifested by its citizens to make it any more than it is." To this insult Allison could only protest in his own paper, the *Brown County Democrat*, on September 28, 1905, "You're a liar! Nashville has been incorporated for thirty-five years."

In one of the gentler ironies of history, the future viability of Nashville was assured by a group of individuals who came to town only because they had been led to believe that Nashville manifested no energy or enterprise. Word of Brown County had been circulating among professional artists for several years, and a

few had made tentative forays into the area. In 1907 the eminent landscapist T. C. Steele bought some land on an abandoned ridge south of Belmont and began to build a fair-weather studio retreat for himself and his wife. As if this were a signal, in the summer of 1908 over 25 artists arrived in Nashville, registered at the local hotels, and commenced painting landscapes.

These artists were attracted from Indianapolis, Cincinnati, Chicago, and small Midwestern cities such as Muncie, Indiana and Charleston, Illinois. Most came by themselves or in groups of two or three; many had not previously known one another. Walking the eight miles that separated the railroad station at Helmsburg from their lodgings in Nashville came to symbolize to the artists their escape from civilization. They returned in succeeding summers for a few weeks or months of residence, forming a camaraderie during convivial meals and long, languid evenings at the Pittman Inn, the Mason House, and the Ferguson House. They brought with them a spirit of fun and adventure quite unlike the mood of the regular clientele of traveling salesmen and trial juries. During that first summer of 1908 the hotel owner Bill Ferguson, while on a buying trip to Columbus, purchased a pair of fancy sitting benches. He placed them on the front porch of his establishment, to accommodate the endless sociability of his unexpected guests.

Within a year some of the artists, notably Will and Mary Vawter and Adolf and Ada Shulz, began building summer studios or permanent homes in the immediate vicinity. Among their wealthy patrons it soon became fashionable to buy a weekend place near Nashville, and before long a clique of Indianapolis businessmen and attorneys had completely taken over Jackson Branch Holler on the outskirts of town. Of these men from Indianapolis, the most significant for the future of Brown County were Fred Hetherington and Richard Lieber.

Fred Hetherington was among the first aesthetes to come traipsing through Brown County. As a youth he had studied painting and drawing, and he distinguished himself as the first newspaper cartoonist in Indianapolis. Although he considered the life of an artist, he eventually became a partner in an iron foundry and construction firm. In 1908 and 1909 he often joined the artists at the Pittman Inn, but then he started a trend by acquiring the old Harrison Lucas homestead on Jackson Branch. The German immigrant Lieber was a music and theater critic who made his commercial reputation as an insurance reformer. Shortly after he built his chalet up the holler from Hetherington he resigned from business to devote himself to public service and the establishment of the Indiana Department of Conservation. These two gentlemen did their part to create the twentieth century, yet they both idealized the rural past and encouraged the artists.

The rise of the Brown County artists' colony makes a good story, which would require another book to tell. What is most important to understand is

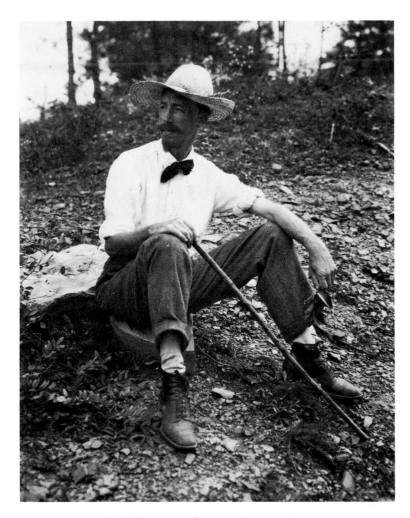

Adolf Shulz first visited Brown County in 1900;
he visited again in 1907, then returned the
following summer with his wife, Ada, who was
also a fine artist. He became a permanent resident
and was influential in establishing the tone and
direction of the Brown County artists' colony.
This photo was taken about 1913, during one of
Hohenberger's first trips to the county.

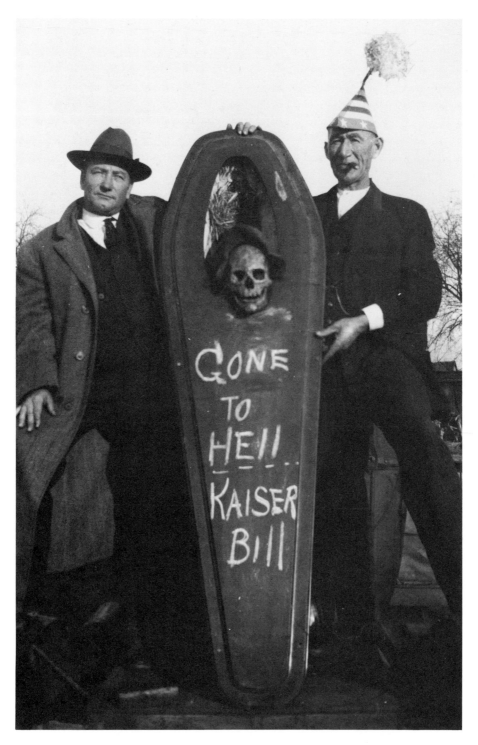

County Prosecutor John Wright and David Blume at the Armistice Day parade in Nashville. The coffin was donated by the undertaker, the skull by the town's dentist. The marchers carried the Kaiser down Main Street and threw him on a bonfire. Harry Kelp sang and T. D. Calvin beat on a bass drum while he burned.

that the members were attempting to recapitulate the innovative art movements of nineteenth-century France. But ideas and sensibilities that were radical in Barbizon during the 1830s and 1840s, or Giverny during the 1870s and 1880s, were conservative in Nashville during the 1910s and 1920s. In its inspiration Nashville was similar to other provincial art centers formed a little earlier on the East Coast, such as Old Lyme, Connecticut; Woodstock, New York; and Provincetown, Massachusetts. Because they spent the winter in New York and Boston, artists at these sites had to be aware of the power of fauvism, cubism, modernism, dadaism, abstract expressionism, and the many other "ism" shock waves emanating from Europe before and after World War I. But in Brown County the painters could ignore the new developments, which had absolutely no appeal in Indianapolis and little immediate impact in Chicago. For this reason Nashville was one of the very last outposts of American tonalism and impressionism.[3]

In the early days of the colony, although the artists knew exactly what they were doing, they had a difficult time explaining themselves to the public. With their late-Bohemian berets, floppy silk ties, Vandyke beards, and cigarettes, the artists talked about the moods of Nature and the grace of peasants. Standing for hours with their easels in creek beds and cow pastures, they seemed at best exotic and at worst laughable. By 1912 tourists were beginning to make excursions to Nashville, but at first they came not to see the hills or the hillfolk, but to see the artists at work. Only gradually, by looking over the artists' shoulders, so to speak, did they learn why and how they should be fascinated by Brown County. And gradually the townspeople learned to provide for the needs of the curious strangers. Bill Ferguson died in 1912, and his hotel was sold. At that time Dennis Calvin, the County Sheriff, took up a collection to buy Ferguson's porch benches, which he set in the courthouse yard as a resting place for the strolling tourists.

The artists considered the tourists distracting nuisances, but they realized that some were willing to be converted to the artistic point of view. In effect the artists' task was to convince these potential new customers that in Brown County the bald, farmed-out ridges and densely wooded hollers were not depopulated wasteland; they were Nature. Furthermore, the original log houses were not squalid, dilapidated huts but charming, hand-crafted cabins; and the inhabitants were not cultural degenerates but precious relics of a better age. It was also necessary to give the impression that the Brown County folk were not suspicious and hostile toward strangers but gracious and hospitable.

These changes in attitude amounted to a complete inversion of the stereotypes about poor rural areas. It is doubtful that they would have been widely accepted in Indianapolis, had it not been for the coming of war. The disorienting horror of World War I made appealing the idea of a perfect society, surviving in

pristine beauty and innocence in the southern hills. In a letter to Hohenberger, a Miss Elizabeth Scruggs described a hack ride in 1916 from the railroad station at Helmsburg to Bear Wallow, the home of Marcus Dickey:

> How beautiful were the hills and what a perfect picture they made. . . .
>
> En route we passed many typical Brown county farm houses, a one or two-room log house with the modern ambition of a leanto. Instead of a windmill or an iron pump, a well sweep and an old iron bucket which hung in the well in the old days still does duty, and the genial owner served us as daintily as would be possible anywhere.
>
> A hen's nest lying along the road was all the proof we needed of the honesty of neighbors and tourists. The owners of the little farms among these hills seem more than contented with their lot. They live in a little world of their own in brotherly love and fellowship where the spirit of competition is unknown. Keeping up with the styles, the movies, the drama, music, late books and even the war, have no place in their daily routine, and without all of these they have a peace of mind we know not of.

Here the necessary complex of ideas is fully developed: in Brown County was to be found a lost community of geniality, honesty, contentment, and love. After the First World War this complex flourished among the upper middle class throughout the United States as a cult of the pioneer era, inspiring the first back-to-the-land movement of modern times. With improvements in the highway, Nashville was a convenient one-hour drive from Indianapolis, and by 1923 Sunday afternoons in October would bring in 4,000–5,000 automobiles, whose occupants would search along town streets and back roads for the naive virtues of the past.

Of course the belief that the people of Brown County were undisturbed by fashion, competition, and world events was nonsense. As Hohenberger recorded in his notebook on March 25, 1919, Brown County raised over $130,000 in Liberty Loan Bonds, War Fund appeals, and War Saving Stamps. The county sent 189 young men into military service; ten of them died from wounds or disease. Many of the veterans used their bonus checks to buy automobiles in which to leave the county in search of city jobs. For those left on the marginal farms, money was a constant worry.

The daily rivalries of Brown Countians involved not only economics but also politics, religion, and family life. County government was controlled by the Democratic party, despite fierce opposition by the Republicans and other minority parties. In the countryside several fundamentalist sects battled for the souls of the people and joined together only in their contempt for the established town denominations. The traditional, male-dominated society contained much hidden hostility between men and women, heightened by the women's rights movement of the 1920s.

16

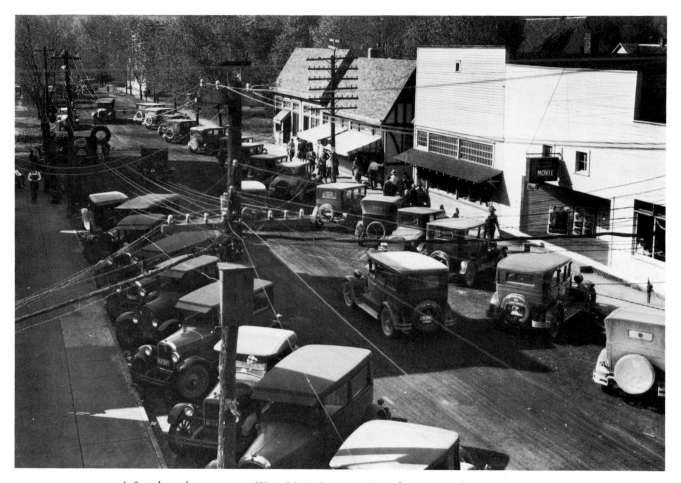

A Sunday afternoon on West Main Street in October 1927, photographed from the balcony of the corner drug store. The movie theater opened in 1924 and was named after Melodeon Hall in Kin Hubbard's cartoons. The last two buildings on the left housed the gallery of the Brown County Art Gallery Association, which opened in 1926.

Whatever their particular affiliations, the older men wanted Brown County to continue as an insular, conservative place; in their dealings with outsiders they did not wish to be considered a special case. Despite the shock of the war, votes for women, bobbed hair, short skirts, knickers, college jazz, and Prohibition, these men continued to persist in their time-honored customs. For the county as a whole, the most important customary gatherings were the Old

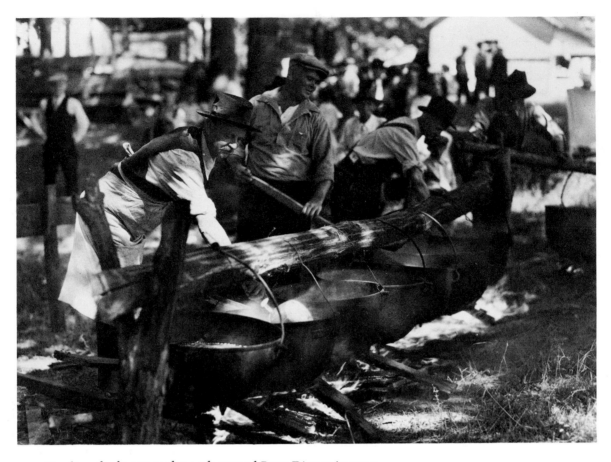

Tending the beans at the 44th annual Bean Dinner in 1931.

Settlers' Reunion, held since 1877 on the first Saturday in September at the Waltman Grove near Bean Blossom, and the annual Bean Dinner, held to commemorate veterans of the Civil War every August since 1887 at the Schooner Valley cemetery. From an insider's point of view, the most important event of the 1920s happened in 1925, when the Southern Indiana Fox Hunters' Association chose Nashville as the site of its annual October convention. Fox and raccoon hunting were popular recreational pursuits in Brown County, and the convention brought the sort of attention that the common man could understand and be proud of.

Those who persisted in trying to make a living off the land were advised by A. E. Grubbs, the newly arrived Agricultural Extension Agent, to try innovative specialty crops like apples and tobacco. The old-time farmers grumbled about

18

taking directions from a college man, but they accepted his ideas more easily than the ideas of those who proposed that tourism would be the salvation of the county. In the last year of his life Lon Allison had a good sense of the future, which he shared in an editorial entitled "Our Tourist Crop Needs Cultivating" in the *Brown County Democrat* of March 26, 1925:

Tourists think that Brown County is beautiful and picturesque. No matter what you think it is—you are just an "old hayseed" that was born and drug up here in the hills. Hills are nothing in your young life and you may not realize that other folks like to get a change from the level streets of Indianapolis. . . .

Those of you who think that the tourist is a town crop—don't overlook the fact that the tourist is a crop for everyone who cares to cultivate him. He (and she) has money. Money that burns great holes in his pocket. This money craves to be spent and you no doubt have things that the tourist wants just the worst way.

Maybe you don't realize it but the tourist offers a wide market. He buys fruits of all sorts, vegetables, eggs, butter, chickens, all kinds of food products. He buys rag rugs and spreads and quilts and old furniture and quaint baskets and new furniture made in a picturesque way from hickory poles, and bird houses and hound pups—in fact the tourist will buy darned near anything you offer him. . . .

AND ANOTHER THING—whatever you sell to Mr. or Mrs. Tourist be certain that it is of good quality. If it is fruit, let it be sound fruit. If it is a rag rug or a piece of homemade lace, let it represent the best that you can do—be proud of your product and let it be a product that you CAN be proud of. Don't try to cheat the tourist trade. Don't short change 'em. Don't expect 'em to eat what you would not eat yourself. Don't OVER charge 'em. In fact treat the tourist as tho you expected to be a tourist yourself some day. Such a program will do more to build up Brown County than if we were to strike oil at the two hundred foot level.

In addition to new cash crops and tourism, there was another "program" available to the people of Brown County. The hazy hills contained some excellent timber, and the same highway improvements that made it easy for tourists to get to Nashville made it possible, by 1922, to haul logs, railroad ties, and sawn lumber out of the county by truck. Commercial sawmills were established in several valleys, and many farmers began to clear-cut their woods. The logging operations alarmed the artists and those in Nashville who catered to the tourist trade, not only because the cutting disfigured the landscape but also because the dragging rigs and heavy trucks turned the back roads into deeply rutted tracks that were impassable for the automobiles of sightseers from the city.

In the midst of the conflict over the timber business, the artists and some other newcomers became enthusiastic about the idea of some kind of sanctuary

or park to protect the scenery. The thinking was that if the natives didn't realize the spiritual value of the trees, then the land should be taken away from them. Since 1916, with the formation of McCormicks' Creek State Park in Owen County, Richard Lieber had been working to establish a series of state parks throughout Indiana, administered by the Department of Conservation. In 1924 he authorized Lee Bright, Nashville's only real estate agent, to begin secretly securing options on farms in the vicinity of Weed Patch Hill. Because of problems with the state legislature, when Lieber announced the plan in 1925 he claimed merely to be setting up a wildlife preserve. By 1929 his department had acquired 14,000 acres, and after some clever legal maneuvering he was able to designate part of the tract as a state park.[4]

The creation of Brown County State Park was a major accomplishment for the idealists among the artists and their following, who imbued the sanctuary with their attitudes toward society. If they could not fix predatory competition in the industrialized cities, they would fix it in the park. In describing the Department of Conservation's policies regarding the wildlife preserve, the *Indianapolis Star* of October 2, 1925 reported:

> Steps will be taken to encourage the life of the desirable birds and game that now inhabit the area. The department will endeavor to rid the reserve of such animals as menace the life of the other animals. Foxes, which steal eggs of birds, will be destroyed, it is planned.

However artificial Lieber's theory of nature, it was more realistic than his theory of culture. On the land taken for the preserve, all buildings and other signs of human habitation were destroyed. Even the crossroads hamlet of Kelp was obliterated. After 1929 the state set about building a guest lodge and a number of housekeeping cabins for tourists. When the lodge and the park itself were dedicated in May 1932, the new buildings were named after Abe Martin and other characters from Kin Hubbard's make-believe world of Bloom Center. The hill folks of Brown County had disappointed the newcomers by not sharing their aesthetic vision and personal values. Through the establishment of the state park the local people were removed from the landscape (or the most attractive section of it) and replaced by imaginary folks who conformed to the pastoral ideal.

Among the real people of Brown County, reactions to the new park differed. In 1924, when real estate agent Lee Bright and Sheriff Sam Parks had gone about the desired territory discreetly asking for options to buy, the landholders were amazed. They found it hard to believe that anyone would be willing to pay five to fifteen dollars an acre for their ground, which was so cut-over and eroded that many farms had simply been abandoned. When the time came to sell, a few old farmers resisted the state, but most were happy to take their compensation and move.

The County Commissioners cooperated with the Department of Conservation, yet a few residents who had not profited directly from the deal had their doubts, especially after it became clear that the preliminary game preserve would become a recreational resort for tourists. In 1928 a debate ensued on the editorial pages of the *Brown County Democrat*. On April 22, 1928 Hohenberger reprinted portions of a letter to the editor in "From Down in the Hills O' Brown County":

> My own people, or some of them, have lived in Brown county, or what is now Brown county, more than a century. They didn't have a state park then, and we don't have one now. Modern science has made changes in the manner of living, but essentially we do about the same thing they did—try to coax a living out of Brown county clay.
>
> There aren't any howling successes among us, but somehow we do move along. We furnish a lot of copy for the outside newspapers, who seem to think it is a form of humor to expose to the public the fact that some of us do not know a split infinitive from a participle ending. Every week the public gets further proof that we are indisputable evidence supporting the theory of evolution, and motorists decide that before another season passes they must drive down into these hills to hear us chatter and paw over each other in search of fleas and swing from the trees by our tails.
>
> We used to love and hate about like any other people, fight a little now and then, keep warm in winter and well-fed all the time. We enjoyed the pure air of our hills, their quiet beauty, the fish in our streams and the game of our woods. Many will say that we merely existed, that we didn't live, but if this be so, why do they want to come now to do these same things? I say that we lived and were happy, and did it without a state park.

As this letter indicates, the educated ones in Nashville had become sophisticated at refuting the assumptions of outsiders. Nevertheless, this writer had accepted some of the rapture of the artists even while denying the uniqueness of the area. Of course not everyone with an opinion was so eloquent. The changes of the 1920s taught one lesson: the fate of the county would be determined by forces beyond the influence of local citizens. Faced with this fact, most of the people affected by the changes did not know what to say.

What does a merchant do with his time when the trade that allows him to stay in business comes mostly on weekends? What does a farmer do with his time when putting in a crop only means going deeper into debt? What do men do when the world is rapidly changing, imposed federal laws alter their social status, and their very town is controlled by strangers with strange ideas? They do what they can do: get together every day, whittle, spit, tell tales about foxhounds, and play horseshoes.

At this point the benches by the courthouse may re-enter the story. For years after they were placed in the courthouse yard by Sheriff Dennis Calvin, the

natives would not sit on them because they were intended for city visitors. But about the time World War I ended, horseshoe pits were dug along the southwest edge of the square, and the benches were carried over to that corner of the yard and appropriated by local men. After a few years of hard use one of the benches fell to pieces; the second one survived, although because of a wobbly leg it had to be propped up against a tree.

As the Twenties roared into Nashville and the national economy boomed, for the men of Brown County times had never been worse. Some, out of a sense of threatened pride and powerlessness, joined the Ku Klux Klan. Others, especially those most active in the Democratic party, made it a practice to gather daily around the bench and affirm by their nonchalance the value of their past way of life. The horseshoe games became a group obsession, a sort of ritual of denial. While they concentrated on a game, time could stand still, and the men kept a game going from dawn until dark, every day that weather permitted for over ten years.

Rural courthouse towns always have benches, known to some as liars' benches, for idlers to occupy. In Nashville there were several such benches; they could be found in front of the post office, the blacksmith shop, the barber shops, the hotels. But when, in the autumn of 1923, Hohenberger published a description and a photograph of the bench in the courthouse yard, it became famous as the Liars' Bench. To the readers of his column in the *Indianapolis Star*, the bench represented the half-forgotten pleasures of small-town life. The bench itself became a celebrated entity; it, along with the log jail and Weed Patch Hill, became the main tourist attraction in the county.

So, while the unemployed or underemployed men swapped stories and played checkers or horseshoes, Nashville was transformed from a marginal farm town into a rusticated resort. During the Twenties one-fourth of the population left the county in search of city jobs, and a favorite excuse for coming into town every day was to check at the post office for money sent home. The rest of the day many men seemed to be loitering, yet they were reluctant to do menial work or help with women's work. This last point of honor was insisted upon by the regulars on the bench, who expected to continue to dominate women even though they had lost power in the larger arena and didn't know how to lead their families into the future.

To the women involved something was vaguely wrong, but, because it was not customary for them to assert themselves in public affairs, they waited for the men to do something. It was puzzling that the tourists approved of the townsmen loafing around and encouraged them with attention. By 1929 the bench in the courthouse yard seemed to be the focal point of a cult of laziness. The women became so disappointed in their husbands that, finally, under the protective ambiguity of Halloween, they took matters into their own hands.

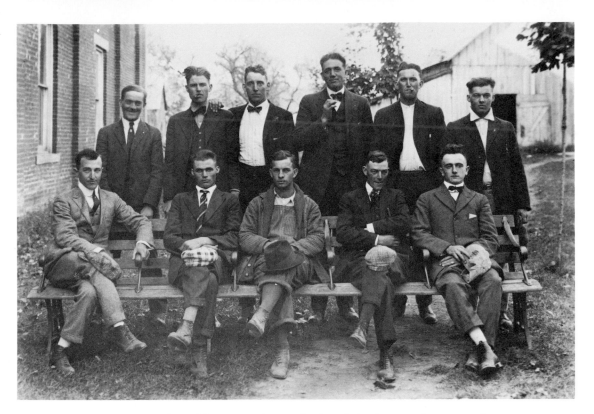

Veterans of World War I gather at the bench in the courthouse yard, about 1920. By this time the local men had claimed the bench as their own.

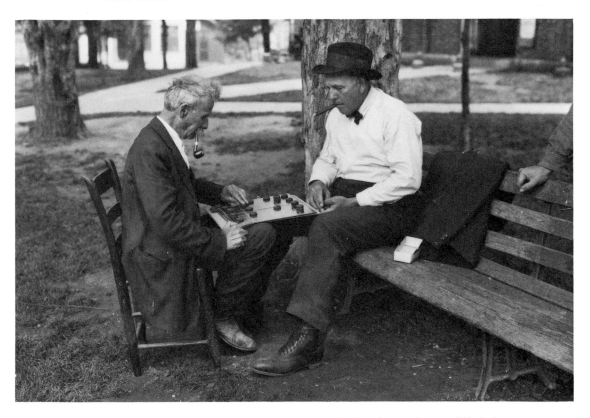

County Auditor Scott Moser and County Clerk Bub Henderson filled the empty space in their daily agenda on the Liars' Bench. Here, they enjoy a game of checkers. The negative is undated; it is probably from the summer of 1924.

Hohenberger didn't mention the destruction of the Liars' Bench for two months. Then, the installment of "From Down in the Hills O' Brown County" for January 5, 1930 contained an item that began:

The morning after Halloween a group of mournful looking men gazed at the remains of the liars' bench in Main Street.

"It's jist too bad," was the most any one could say until Scott Hamblen showed up.

"It's worse'n bad," he claimed. "It's th' ruination uv th' town."

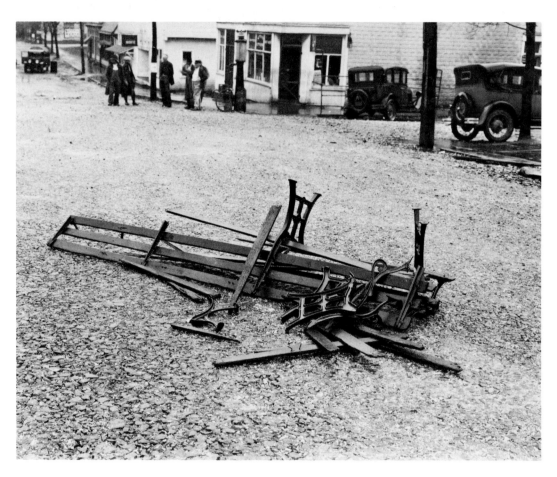

The Liars' Bench as it appeared on the morning after Halloween 1929. The pieces were stored in the shed behind the courthouse. When the weather improved some men laid it out on the grass and spent a few hours trying to wire it back together.

If not the ruination of Nashville, the passing of the Liars' Bench did mark the end of a transitional era. The gatherings of the men were transferred to the back room of the Ford garage. But, in the spring, the horseshoe games were not revived, coming to an end as abruptly as they had begun ten years before. Several merchants took up a collection and bought a surrogate bench, with the words "Liars' Bench" painted conspicuously on the backrest, and placed it in the court-house yard. At first no one would sit on it. The tourists thought it was there for the local folks, but the local folks knew it was there for the tourists.

When the tourists eventually claimed the new bench as their own, they were able to sit at the mythical center of Brown County. Perhaps none were aware of the distress that had surrounded the authentic bench. And perhaps none knew the Brown County characters except by reputation. How well may we know them today? Through the sustained and detailed efforts of Frank Hohenberger we may appreciate the words and images of a select few. Thanks to his achievement we can be better acquainted with these individuals than curious visitors could have been in their own time.

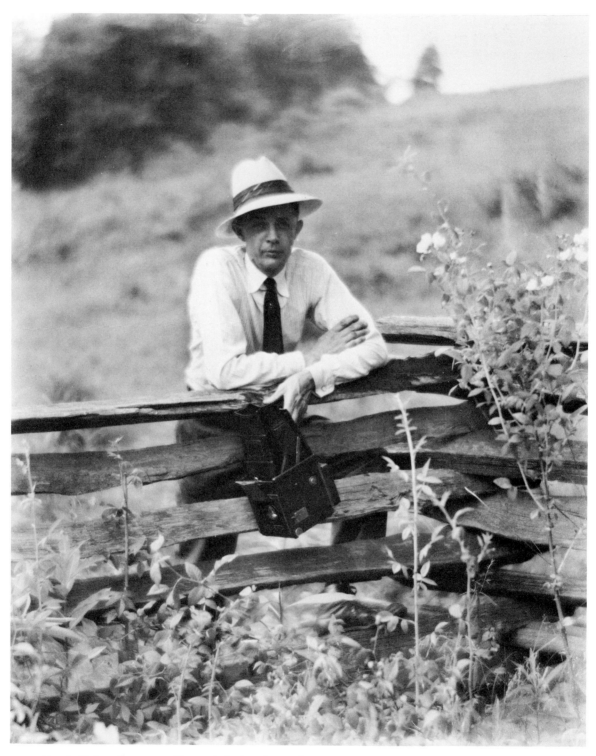

Frank Hohenberger on Upper Salt Creek Road, July 1920. At 44 he was changing his attention from scenes of nature to cultural artifacts and character studies.

Frank Hohenberger

FRANK HOHENBERGER was born in 1876 at Defiance, Ohio. He was orphaned at the age of five, and together with his sister and two brothers he was taken in by his father's parents. After graduating from a German-language parochial school, he was sent by his grandfather to apprentice in his uncle's printing shop, where he learned to set type and operate presses. As a young man he worked for newspapers in several cities around the Midwest. In 1902 he was accepted into the International Typographic Union, and soon afterwards he settled in Indianapolis.

Hohenberger took up photography in 1904, and by 1909 he was doing shooting assignments and darkroom work for an art supply firm, in addition to his regular job as a newspaper pressman. One day in 1912 he developed a roll of film that intrigued him. When the customer returned, Hohenberger learned that the shots of picturesque scenery had not been taken somewhere in remote Appalachia, but in Brown County, just two hours away by train.

During the next few years Hohenberger made several photographic sojourns into Brown County. He worked diligently to improve his technical skills, and he read widely about photography as an art form. His tonalist style of nature photography, emphasizing moist light effects at dawn or twilight, followed Edward Steichen and the Photo-Secessionist movement in New York. His concern with the rural working class harkened back to the earlier naturalistic aesthetic of the influential nineteenth-century English photographer Peter H. Emerson. Hohenberger was pleased to become acquainted with the artists in Nashville, and from them he became familiar with the conflicting tenets of European Romanticism and Idealism.

Reviewing his life as a whole, one gets the strong impression that Hohenberger experienced a mid-life crisis as he approached the age of 40. Clearly, he wanted a fresh start, a way to do something creative, and a chance to make some real money. In 1916 he left his job in the composing room of the *Indianapolis Star*, where he had been earning $45 a week. He took a job at $16 a week managing a camera shop, but he had other plans. In the summer of 1917 he moved to Nashville, leaving his first career and Grace, his estranged wife, behind in Indianapolis.

Hohenberger liked to think that he was pioneering in camera work in Brown County, but he soon discovered that many of the local folks had pocket cameras, which, after all, had been available by mail order since the 1890s. In Nashville's better days there had even been a portrait studio in the town, and people missed

27

having the services of a professional photographer. For a while Hohenberger survived by selling film, developing negatives, and making prints to order. But he discouraged this sort of work; he had not come to Nashville just to open another camera shop.

From the beginning of his new career as a photographer Hohenberger was interested in the rural landscape and the rural way of life. Every few days he would go on a long rambling walk in the Brown County countryside, carrying a large-format box camera, tripod, focusing cloth, plate holder, and notebook. Frequently he had so much equipment he had to rent a pack pony. Some days he stayed around Nashville, watching people and listening to talk. In the evenings, alone in his studio, he typed his notes onto uniform pages of heavy, legal-size paper, and he worked at his photographic prints. Within a few months he was selling pictures to tourists, learning that scenes of log houses, especially archetypal ones with shingle roofs and exterior stone chimneys, sold better than his views of nature.

In the tradition of Jean-François Millet in France, William Morris in England, or Leo Tolstoy in Russia, Hohenberger could rhapsodize about peasant life. But he showed a penetrating curiosity. He was willing to stop and talk with the men and women he met on the back roads and to accept their hospitality. He began to go on house calls with Doc Turner, Nashville's only physician. Up close, he was repulsed by filth and disease in the wretched houses of the poorer families.

Privately, Hohenberger remained ambivalent about the hill folks. He could not share the prejudice of society's leaders in Indianapolis, who dismissed them as poor white trash; nor could he completely accept the assumptions of his artist friends, who revered them as living survivals from the pre-industrial age. But publicly he played along with the rising nostalgia of the middle class. As he said in a lecture to the Indianapolis Nature Study Club in December 1919, he intended to "photograph the old things which are fast disappearing. . . . When you picture something that takes the observer back to boyhood days on the farm, you have hit the vital spot in the region of their pocketbook."

By the early 1920s Hohenberger was well established. He sold prints through a display at T. D. Calvin's general store and also by mail order. He was able to place photographs in newspapers and popular magazines. In the spring of 1923 he proposed a regular weekly column to the publisher of the *Indianapolis Star;* it began to run in June of that year under the title "From Down in the Hills O' Brown County."

In Hohenberger's columns Nashville took on the aura of fiction. The main intersection, where women would gather during their trips to the town pump, he named Gossipy Corner. The road west out of town, which was walked twice a day by women who milked cows in their outlying barns, he named the Milky Way. The bench in the courthouse yard he designated the Liars' Bench. The

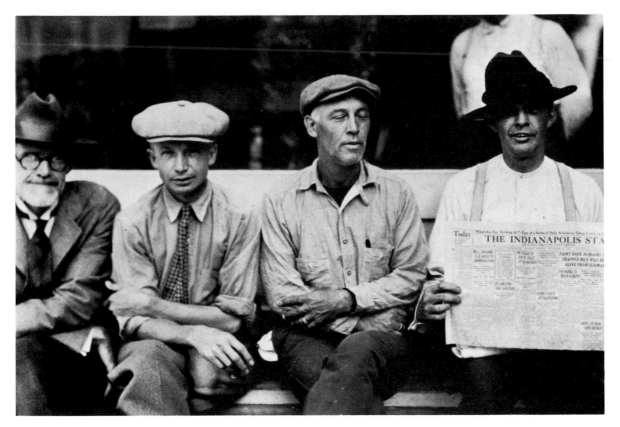

Hohenberger getting the news on the bench in front of the post office. This snapshot is in a box of miscellaneous prints in the Hohenberger Collection; the date and photographer are not indicated.

town itself he often referred to as Peaceful Valley. Several persons were half-disguised: Harry Kelp appeared as Carey Help, Buck Stewart as Stew Bucket, Sam Parks as Park Sampson. For the amusement of his readers Hohenberger did not hesitate to publish details of the court trials, family feuds, and personal idiosyncrasies he observed around town.

In Nashville the reaction to this new wave of publicity ranged from mild irritation to outright anger. In the minds of the local people Hohenberger had condemned himself forever to the status of resident alien. There were a few exceptions to this rule during his lifetime, but even today elderly persons in Nashville who remember Hohenberger will insist that he was never accepted by the town as a whole, in contrast to other, more considerate newcomers like

29

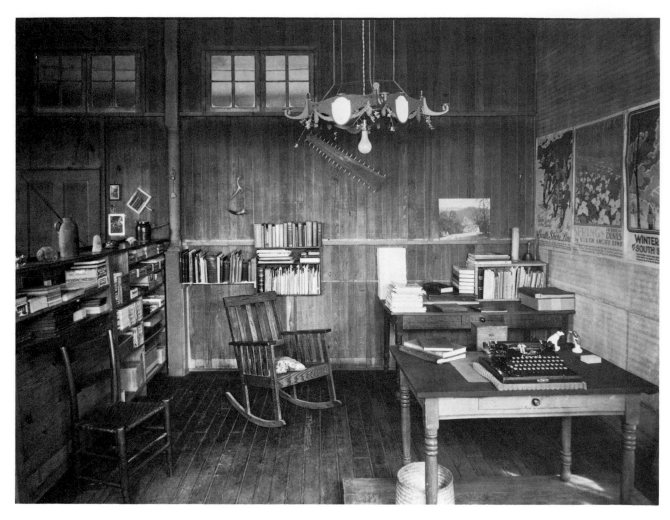

Hohenberger's studio in the abandoned Odd
Fellows Hall, February 1932.

Will Vawter and Carl Graf. This deeply negative reaction surprised and disillusioned Hohenberger. He began to see his detractors as humorless bigots, no different from people anywhere else. For his own part, he remained stubbornly insensitive to the fact that he was causing the problem.

Hohenberger was a solitary soul, with no intimate friends. Although he began a sort of loose-leaf diary shortly after his arrival in Nashville, it was an impersonal record. In his writings he rarely mentioned his feelings, and except for a few scattered memories of early boyhood, he never alluded to his past. In September 1918, perhaps in response to a letter from his former wife, or perhaps to no one but himself, he wrote:

> With the tick of the old clock on the wall, the song of the tea kettle, the right to get two slices of thickly spread buttered bread, and a touch of apple butter, and no one to tell you to keep away from the larder of choice jellies. A bushel of hickory nuts and walnuts, and rosy red apples. The evenings never long when you can dream in the light of the glowing embers. Never lonesome—I don't know what you mean.

During the next few years Hohenberger knew what lonesomeness meant well enough to spend a great deal of time with Doc Turner's daughter, a pretty young schoolteacher named Beryl. In the winter of 1921 she abruptly disappears from his writings. The following summer he quietly married a woman whom he mentions thereafter in his notes cryptically and infrequently. Her name was Kathryn Banta. For a year they lived together in Nashville. Then, shortly after his articles began to appear, they moved to her home in Martinsville, the seat of Morgan County, 25 miles northwest of Nashville. Hohenberger maintained a studio in Nashville and rigorously persisted in photographing and writing about Brown County. By 1930 he had separated from his second wife and taken up residence in his studio, an arrangement that continued until his death over 30 years later.

The problems of marriage and antagonisms between men and women were constant themes in Hohenberger's writings. It is no accident that the people he did become close to around Nashville were social misfits: bachelors like Chris Brummett and Harry Kelp, spinsters like Molly Lucas, bitter widows like Allie Ferguson, or disbelievers like Sam Parks. Hohenberger may have been too inhibited to succeed as a family man, but he did become devoted to Nashville. His adopted hometown did not embrace him, but for the rest of his life he believed he belonged there.

The town that Hohenberger loved existed partly in reality and partly in his imagination. As time went on, the part that was real came to be more valuable to him, even though his standing in the community remained full of vagaries. As he was told on the street one day, "Misdeeds never get too old to be forgotten."

31

The natives were never harder to understand than when they were talking directly to him. The following items from Hohenberger's diary notes pertain mostly to the controversy regarding "From Down in the Hills O' Brown County."

Ellsworth Crouch came at side door Jan. 3/19 and had several dogs with him. He wore a hunter's coat. Very shabby looking. As he came in I wondered what he wished and whether I could get rid of him very quickly. Had a roll of film and wished to see me develop it. He had a small outfit from Sears Roebuck. I needed 3¢ to pay Daddy Woods for pkg to Helmsburg and didn't wish to go to bank. This boy turned up at 2 O'clock and saved the day. Left order for 75¢ worth of dev. and ptg. Bought a book on Photography, also wanted to know if I had the Fillins'. He purchased three rolls. No, you never can tell by a feller's clothes. Told me about the Chaffin house also another near Crouch's home at Kelp.

Star editor wanted faces changed so that one could not recognize the natives I depicted. He should know that we are able to tell who the other fellow is by the clothes he wears—wears the same ones all the time. The face may change, but the clothes—never. (May 1923)

I had an article about Sam Parks' wife in Star Jan. 13 and he said she was looking for me with a knife. Had prepared a practice dummy my size so she could work accurately. (1924)

Ben Seibert said to Dick Jones, "I don't like that feller. Ain't you been reading about what he has in the papers. Ain't it awful?" Meaning me. (January 1924)

Lon Allison refused to lambast me in his paper in response to some narrow minded people. He said "The truth is what's cuttin' 'em." (January 1924)

We were rehearsing Snyder's accusation about lies and Allie said: "It's bad enough to tell the truth about the place, let alone lie." (January 1924)

I had frequently asked Louis Snyder to give me a story for The Star in which he would give some of his experiences as a truant officer, statistical as

well as humorous. He refused and finally I asked him why. He said I had printed so many lies and would add to his article or manipulate the same, I presume. . . . It was agreed that we meet at his office Thursday morning, January 31, 1924 but at 6 o'clock Wednesday evening, January 30, 1924, he came to the Studio and wanted to talk things over—nothing along the line of losing one's head, etc. I told him all I wanted him to do was to sit in that chair and keep his feet on the floor. I started to ask him about 25 questions but he wanted me to promise that I wouldn't print what was to pass between us. I gave him my word as a gentleman. . . . His answers were pitiful. He finally admitted that he didn't understand my items. I explained them and he could see clearly. Acknowledged his ignorance of human interest and humor. . . . He finally admitted that at some time or other in a barber shop while he wasn't feeling good I had said something to hurt his feelings. He had harbored that for a long time and finally saw a chance to injure me. He admitted that he had been mistaken about me meaning anything by it. Wanted to know if I would print items about the school system. And would I give Brown County boosts. Outsiders were offended or were getting wrong impression of the county. The more we talked the more disgusted I became but I tried to hold myself within reason. . . .

We finished about 7:15 and when he left the place he asked me to forgive him what he had said about me. Not necessary to say that I did.

T. D. Calvin said some folks objected to being called natives. That it would be proper to refer to Filipinos in that way. When I told him that in a history of Morgan, Monroe and Brown counties his parents were referred to as natives of Ohio and Illinois he didn't have any argument but added that they never sold him another book. (February 1924)

Bill Hoy's wife had been reading my Star articles and when she asked Allie why she didn't whip me Allie remarked that my stuff was all right and incidentally said to herself "It's a good thing he wasn't here when you cut up with that married man, Parks the jewelryman." (February 1924)

Nannie Calvin, June 9/24, said some man from Indianapolis was complaining about the people of Brown County being behind the times about 200 years. Raved about everything but the wet weather—he knew they were having a dose of the same thing back home. Nannie told him if he didn't like to go back home, and that if he didn't look out he might get egged out for finding fault. . . . Nannie told the furriner that the reason Brown

County was so bad was on account of so many Indianapolis people locating here. Nannie told me that she thought I was ruining the county by telling tales about the people, that I selected the most degrading subjects, that readers would judge them as representative of the rest of the folks here, that I ought to write up leading citizens—Jimmy Tilton and Bill Coffey, for instances. Objected to my using the dialect—said only the older people used it.

Iv King was approached by a visitor who wanted to know where I was and did Iv know me. Is he the fellow that writes that Brown County stuff. Iv told him I was and that some folks got offended at the writings. But said Iv, Frank's a good fellow and I like him, and that's why I don't read his stuff. (October 1925)

Sam Shuler of Martinsville, Elijah Lucas, former county recorder here, also a preacher, jumped me about making photographs, claiming the bible spoke against it: Graven images, etc. John Allison told Carl Graf in court house yard that I got my information for my stories from the ignoramuses and not the intellectual class. Tom Snyder said if he had the money he would prosecute me for writing the stories. John's father gave me lots of stories. Allie Ferguson always asks critics whether they read my stuff. Says if I told the truth there would be some fun. They are never obscene, however, and I have never been asked to apologize for anything I sent in. (August 1927)

The following letter was sent to the Democrat *by A. Merriman, but was not published: "Dear Sir: The writer for* The Star *has been giving us some hard ones on our progressive ways of late. Has he been sent to Brown County to make us over! If we were his kind would his furriners find us as interesting! Or is he trying to make a hammer out of a pen! If his father and mother and all his kin folks were born here in our hills would he write about us as he does now! His superior way of 'showing us up' is very objectionable to some of us who love the dear old county that gave us birth. Why is he tolerated by any loyal Brown Countian!" (March 1930)*

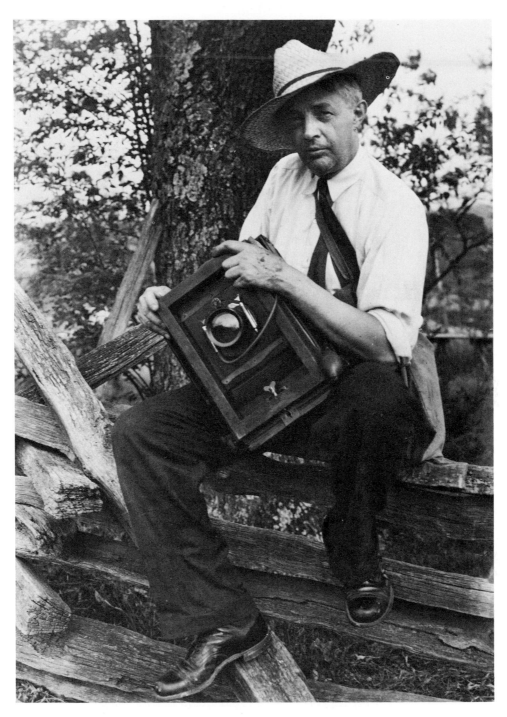

Hohenberger at the Snodgrass home, May 1933. The Snodgrasses were the first city people to have a log house dismantled and moved to a new location. This process has since been repeated hundreds of times in Brown County. Hohenberger aged quite a bit in the years covered by this book. In the 1930s he discontinued his hikes and began taking long auto tours to other parts of the continent.

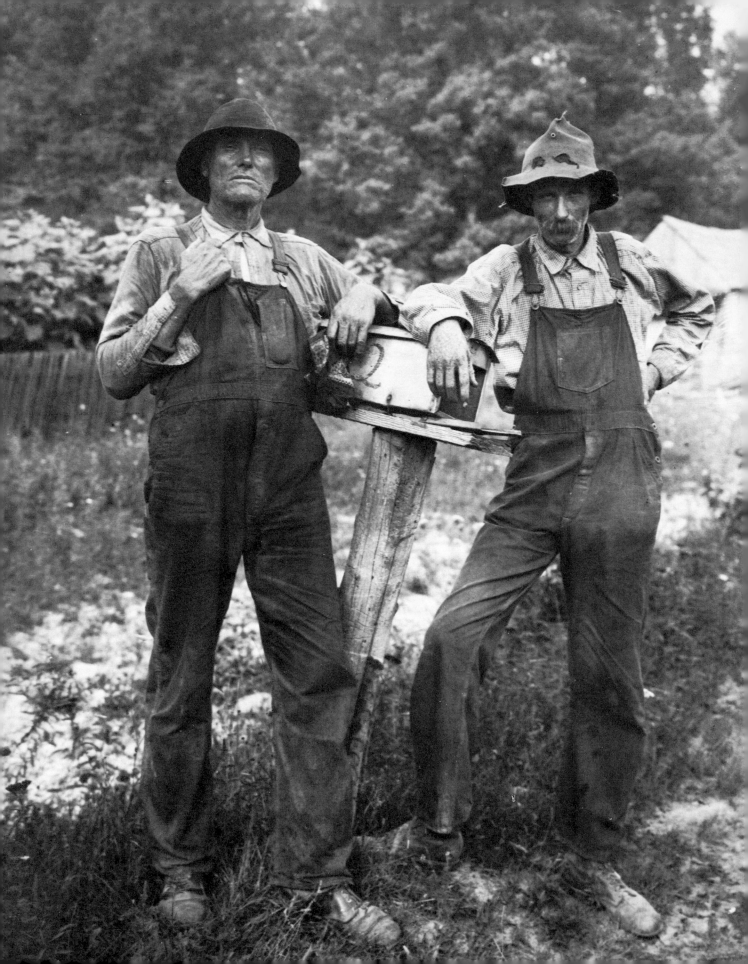

Chris and Felix Brummett

HOHENBERGER had not loitered around Nashville long before he noticed an especially interesting character riding into town on horseback. This individual was living proof of the Abe Martin caricature if there ever was one: tall, lanky, slouching, with a tattered hat, drooping mustache, patched overalls, and loose boots. Making some inquiries, Hohenberger discovered that the man's name was Chris Brummett and that he lived with his brother, Felix, out toward Starve Hollow in the western recesses of the county. Hohenberger became convinced that he had to meet Chris Brummett after he also learned the surprising fact that this apparently illiterate rustic held the office of County Clerk.

Soon Hohenberger made the acquaintance of the Clerk's Deputy, a town dweller named Tom McGlashen, who introduced him to Felix Brummett on the street one day. Felix said to him, "Come on out, the old squaw is feeling fine and we'll have some hot biscuits." So on the last day of September 1917, with Tom McGlashen and his wife as guides, Hohenberger set out on his first ethnographic excursion. He did not take his large outfit, but he did bring along a small amateur's camera. After returning home, he typed up extensive notes about what he had seen and heard.

In their first conversation Chris Brummett revealed himself to be an agile thinker who was in effect an anarchist. As he said, "The people who pay the bills wear overalls," and he was trying to eliminate all imposed taxes and rules from his life. He ignored the new fish and game laws and claimed that if arrested he would pragmatically say to the judge, "Guilty or not guilty? That's what I'm here to find out."

There was more than idle political theory motivating his attitude. The Brummetts' crops were failing again, as were the crops of most of their neighbors on the exhausted soil of Dubois Ridge. Their farm, which had been in the family since 1832, was heavily mortgaged and in danger of being seized by the bank. Federal and state policies were not sympathetic with the plight of struggling farmers, and Chris Brummett ran for Clerk in 1915 with the understanding that if elected he would favor poor folks in executing his court-related duties. He polled 859 votes, mostly from rural townships, and won easily. Although he would come into town to fix up a marriage license, he was always far behind in his other work. His deputy was actually a substitute clerk hired by the exasperated County Commissioners to do Brummett's job.

The vanities of society were represented to Chris Brummet not only by Washington, D.C., and Indianapolis but also by Nashville. Even though his

Felix and Chris Brummett at Jim Fry's mailbox down the road from their farm. They were photographed by Hohenberger on August 10, 1925 while he was on a nature hike.

grandfather George Brummett and his great-uncle Banner Brummett had been founders of the town and had donated land for the courthouse, he identified not with the county seat but with the neglected rural districts. As he told Hohenberger, he wouldn't be caught dead wearing a stiff collar. One of the age-old complaints (and compliments) regarding country people is that they are simplistic, and while that was certainly true of Chris Brummett, it is fair to note that his reactionary minimalism made sense. Here is a sample of his opinions, as set down by Hohenberger after their first visit on September 30, 1917:

> Pride and education run away with the world. Go to be hungry. Sell every hog and even the old cow to keep their girl as finely dressed as Bill Smith's daughter.

> Christ never established the Methodist Church.

> Education: We put confidence in men who are smart and they get all the profit. Schools teach children things parents don't want them to know, or don't want 'em teached.

> New books at school. What's the idea of new geographies? Indianapolis is at the same place, the Ohio river is where is always was, etc. Just some little new-fangled idea makes the change. We know there's a new president every four years. Same way with a governor.

> They recollect there are 12 apostles. But who can name 'em?

One problem with simple and rigid categories is that the world, even the world close to home, rarely accommodates them. The following spring the woman Felix referred to as the old squaw sued him for divorce. Hohenberger attended the settlement hearing, and his version of the proceedings is an excellent example of his early personal journalizing. This diary entry is a vivid account of an unassuming person in the court of those willing to wear stiff collars. Nearly four years later Chris Brummett reminded Hohenberger it was still the case that "Educated folks is beating us." He didn't know how much worse it was going to get.

Chris Brummitt came to town, told Allison "I am going to run for Clerk and I want some printin' done. I've got my horse and I'm goin' after the nomination. There's a lot of crooked ones agin me, but I'll git her." Several days later he showed up at a public sale and went around swearing in his rough and uncouth manner. Shortly afterwards the citizens in that neck-of-the-woods came in to tell the editor that it wouldn't do to run sich a man for Clerk. The editor reported the same to Brummitt who in a few days showed up in the same neighborhood that had held the sale. This time there was a religious meeting in progress. Chris occupied one of the front seats, almost

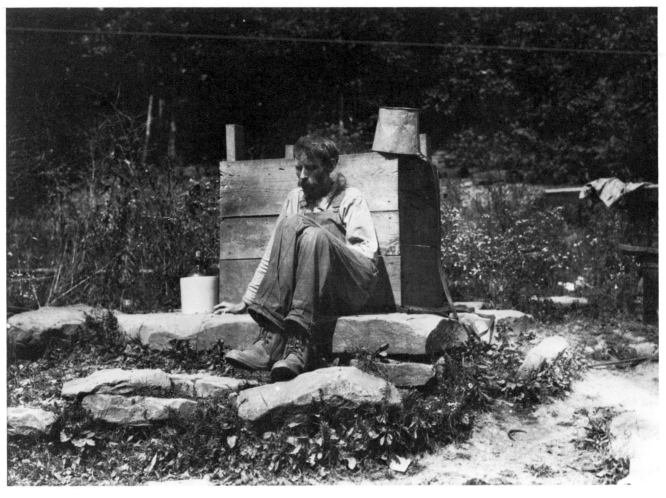

Chris Brummett at his well, snapped by Hohenberger during his first visit in September 1917.

assuming charge of the singing. And he is some warbler. The editor had visitors the next day. "Say, Chris is some singer, ain't he?" "Yes, and he's a good man for the clerk's office." "Well, I guess you are about right." Brummitt polled one of the largest votes ever received in the county. He hasn't been in his office for seven months—he has an efficient deputy in Tom McGlashin. (September 1917)

At the court house in Nashville, March 15/18, listening to the argument for allowance, etc., in Felix Brummet case. A bright day, sun shining through the room, long wooden shutters back of judges seat only. He smoking a cigar, while the deputy clerk was seated in the northwest corner whittling a stick. Jim Jones represented the defendant and Anderson Percifield the plaintiff. Clerk had gotten very far behind with posting books and the case was delayed for half an hour. As I entered the court room there were only a few people—the Judge listening to the clerk's report on cases to be tried, and the sheriff was seated gazing out of the northeast window. The plaintiff's attorney wore a long black sack coat, light-colored vest, clean collar, and he remarked that he was fatter having to purchase a size larger collar. The other counsel wore a white collar also, smoking as usual. The seats in the rear were occupied by about twenty inquisitive ones, among them the liveryman, ready to transport any who might be sentenced to Michigan City. As I started up the stairs some one suggested that I attend court as there were several divorce cases coming up and I might be able to pick up a sweetheart. Entering the court room, Shulz and myself were spied by the Judge and he asked us to occupy the jury box. The deputy prosecutor sat in front of us viewing the complaint. Finally Percifield cleared his throat with difficulty and began to tell the Judge what he thought his client and himself were entitled to—$300 attorney's fees and $15 a week for support of two children and the mother. One of the children was the fruit of a previous marriage of Mrs. Brummet's and the Judge ordered that they forget about that child as the court could not order anyone to support someone else's child. Percifield added alot of bull about taking good care of children nowadays as we in future years needed strong citizens for war purposes. Then Jones took a rap at opposing counsel who contended that Felix was worth $8,000. A sworn and signed statement showed that Brummet was worth between $700 and $800. This included his interest in farm implements, land, provisions on hand, household goods, etc. Jones mentioned that Felix was a good provider, having in mind a statement that there were supplies on hand to the amount of $175.00. It was amusing to see Percifield prancing back and forth in the court room, followed by Jones, who was defending Felix. Percifield was hard to find part of the time—rather wanted folks to bow to him. Finally the

*judge asked the attorneys to get together on the allowance, which they did
after much dickering. Anderson wanted more money and Jones finally came
down 50 cents lower than he had agreed with his client. Then P. yelled to the
Judge to fix it. Jones sparred for more time and then P. asked Jones to let
Judge fix amount—then neither one of them could be held responsible by
client. A little more dickering and the Judge heard this: "Six dollars a week
for support of mother and child, and $25 for preparation of case, Brummet to
see child Sunday afternoons at 3 o'clock for one hour, at the home of Mrs.
Chafin." While occupying the box seats Percifield came over to tell story
about Banner Brummet, Jr., uncle of Felix, who died at the age of 113. When
106 years old he had purchased an Indian pony and was riding it along a
roadway, when suddenly a covey of partridges flew up and scared the pony
so badly that it nearly threw the rider to the ground, and it would have been
better had it did so, but one foot was held securely in the stirrup and he was
dragged ¾ of a mile, breaking nearly every bone in his body, at least they
were damaged to such an extent that setting was impossible. The pony was
so wild that he had to be fed from the barn loft. Banner lived seven years
after the accident, becoming blind a little later, and he passed the time by
trading and repairing knives, getting a little coin in addition every trade.
This was used to buy whisky. He drank only a drop or two at a time, but he
"visited" the bottle very frequently. He was able to cut little pieces of metal
to repair the handles and used a little hammer to drive the little irons home.
To this day it is said the pounding can be heard. How P. could hear it, as he
says, is still a mystery as he is unable to hear even the opposing counsel
unless he gets right on top of him. During the argument the Judge was
obliged to correct both sides, showing that they were not very well posted on
the law covering the case. Felix certainly needed a friend and I was glad to
talk to him about his troubles. Seeing me in the court yard he said: "I came
up as I have a little trou-bull on hand."*

*Felix Brummit saw Shulz on hillside at work one time and told Vawter
the following. "You see I don't know anything about painting but I saw that
big red-whiskered fellow over there and I noticed he had a box with small
things at his feet. He would look up at the sky and then reach for those little
things, then look up again and do some more things with those little things.
As I said, I don't know nothing about what he was doing but it look liked
plum ignorance." (September 1920)*

*Chris Brummit: "When the dogwood is in bloom the suckers riffle." Good
title for a poem. (April 1921)*

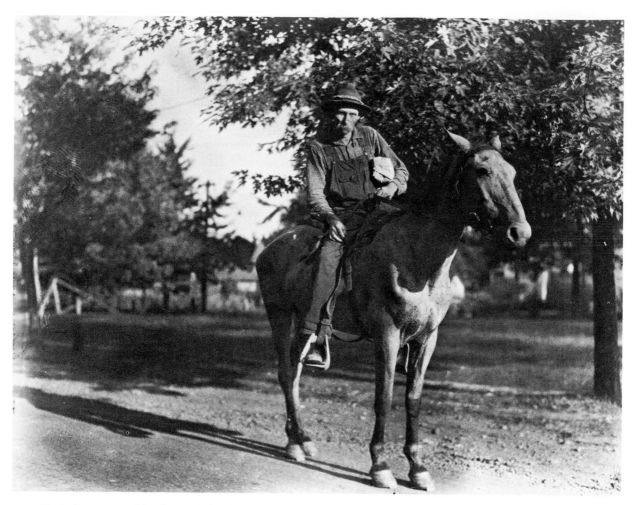

Chris Brummett liked to ride his horse to town.
Hohenberger photographed him near his studio
in August 1929.

Chris Brummet: "Education, Style and Ornerynous is ruinin' the country. Educated folks is beatin' us." The only way to combat that would be to become educated yourself. "That would be a good thing—never thought of that," said Chris. (October 1921)

Chris Brummet came to town on a hot June day—the 28th/24—and some one asked him why he was wearing the rubbers. Said he was doing it for three reasons—to help his bunions, keep his feet dry in the tall grass and to be prepared to pull a machine out of the mud. He was reminded that the fourth reason would be that they kept his feet warm.

Lester Nagley and I went to Low Gap near Marion Sturgeon's and Mr. McGuire's August 10, 1925. Things noted there were jewel weed or spotted touch-me-not, wild hyacinth, yellow variety of jewel weed, nettles grew very profusely, tall brake ferns, also maiden-hair ferns, tall sedges and coarse grasses, many varieties of fungi grew on rotted logs, mosses covered sides of ravine, wild ginger plants, greenbrier and poison vine, green algae on tree trunks, tall trees shut out most of sunlight, mosquitoes and flies in large numbers, ripe May apples, heal-all lined banks of gap, rock cress, big log forming a bridge was about 24 inches wide, fell across gap, glasses perspired, Turkish bath not in it. John Wrightsman was setting fence posts and we happened along just in time for a cold drink of water. Told us about the old Hoover mill and the jices and I got picture of the last post. Photographed the Brummet brothers in front of Jimmy Fry's house at the mail box.

Allie Ferguson on the porch of her boarding
house, October 1921.

Allie Ferguson

As SOON AS Hohenberger set up his bachelor quarters in Nashville during the summer of 1917, he began to gain a reputation as a thorough and tidy housekeeper. The women in the neighborhood, especially, marveled at his ability to cook and clean for himself. At first he even did his own laundering and mending, but before long he hired the regular services of Molly Lucas, an expert washwoman. And within a few years he started taking most of his meals at a boarding house run by Molly's sister Allie Ferguson.

Allie and Molly were the daughters of Harrison and Barbara Lucas, who moved from Belmont County, Ohio, to Brown County in 1856, and settled with their children on Jackson Branch, northwest of Nashville. (Allie and Molly had one sister, Annie, married to Checker Winchester. One brother died in boyhood; the other was killed in the Civil War.) Allie eventually married Bill Ferguson, and they bought a hotel near the county courthouse. Bill Ferguson was active in local politics, and for a time he held the difficult but highly desirable position of Tax Collector. Allie made a career of catering to juries and election committees, in addition to the drummers, or traveling salesmen, who provided most of the business in the late nineteenth century.

By the time Hohenberger became her customer, Allie Ferguson was a cantankerous widow, the proprietor of a small establishment on a side street. Hohenberger was impressed by her defiant personality. She was openly contemptuous of men in general. She scorned all social pretension and political idealism, although she maintained an allegiance to the minority Republican party. She frowned on the emotional excesses of the rural churches, but also complained about the rote ceremonies of the town congregations. She waged a war against changing fashions in music, dress, and behavior, being particularly critical of young women. Few townspeople avoided her moralistic judgment and scathing wit.

Hohenberger escaped Allie Ferguson's contempt; Allie liked him and granted him the privileges of a son (she was estranged from her own two sons). For years he was the only person besides Molly Lucas who was welcome in her kitchen. Even after he married in 1922 and relocated his residence to Martinsville in 1923, he continued to eat several meals a week at her place.

Throughout the 1920s Allie Ferguson was Hohenberger's first and best source of information. As his interest shifted from nature to society, Hohenberger spent more and more time in her kitchen and noted down hundreds of items from their conversations. The topics included current gossip, oral history, legends,

and other lore such as figures of speech, proverbs, weather signs, and home remedies. It is clear that Allie Ferguson enjoyed their talks as much as Hohenberger did.

When Hohenberger's newspaper columns provoked anger and resentment in Nashville, Allie Ferguson defended the aspiring photojournalist. She herself was the subject of a favorable character sketch, published on May 11, 1924.

> The average person marvels at "Allie's" ability to do so many things every twenty-four hours. She makes the two trips down the milky way each day in the year, looks after a good-sized garden spot, curbs the old hog's rooting, keeps posted on all the village gossip, attends church services, never misses a funeral and gives you no complaint about your meals and lodging. She never has time to sit on the front porch and talk with her guests, but you can take it from me that she knows a great deal more about your business that you think she does.

It may be that Allie Ferguson knew a great deal more about his business than Hohenberger thought she did, but it is more likely that he freely confided in her. Surely if this intensely private man trusted anyone in Nashville, it was this equally withdrawn woman. He seems to have understood that her aggressive cynicism masked a complex sorrow and vulnerability. Perhaps a clue to her sorrow is in Oak Hill Cemetery, on the ridge above Jackson Branch, where she is buried with Bill Ferguson in the Lucas family plot. This graveyard is the oldest one around Nashville, and it is now entirely grown up in briars and brush. Next to her stone may be found a marker reading

> MAUDE FERGUSON 1882
> DAMON FERGUSON 1896
> PYTHIAS FERGUSON 1896

Thus it is revealed that at the age of 26 Allie lost a baby girl and at 40, twin boys.

Hohenberger's notebook entry recording Allie Ferguson's own death in 1931 is brief, formal, and factual, as was his style with matters that touched him deeply. The loss of her company coincided with the end of the cultural documentary phase of his work in Brown County. Hohenberger suspended publication of his columns of local color, and except for ordinary commercial portraits and landscapes, he began to turn his photographic attention elsewhere.

Allie Ferguson meeting newcomers at door one evening said: "Wait until I light a lamp. I never like to do business in the dark. Never can tell who's going to choke you." Speaking about Mr. Dickey's stay there she said: "Dickey wrote a lot of Riley's poems. I know. He was here for five months—

46

there wasn't anything else to do. Riley fixed it in his will so Dickey would get the money." (July 1920)

Allie Ferguson meeting newcomers at door said: The beds are all full and the girls don't want partners. On another occasion she was asked whether she got lonesome in the winter time. "Jimminy God no—we have work all the year 'round." (August 1920)

Some one suggested that Allie Ferguson have a victrola in the dining room. "Durn 'em, some of 'em eats too long now," she replied. (September 1920)

When the women found out that Moser had kicked his wife they got up a lot of sympathy for her but the men folks said they thought she had a kick coming—two interpretations. Allie said: "Whenever a man gits it in his head to kick me he'd better make all arrangements for funeral and estate settlin' beforehand 'cause he ain't gonna be here to answer any questions." (March 1921)

Allie Ferguson, referring to her brother-in-law's hurry about getting a new woman said she thought he ought to wait until his first wife's voice died in his ears or until the tracks were out of the yard. (March 1921)

I find that it pays to give a good survey of things in the kitchen, especially as to how Allie is feeling, before one opens up their head. I generally have a bit of scandal to relate and that opens the way to a lovely dinner hour. (April 1921)

Allie F., when told about some evangelist pulling down a big sum for preaching the gospel commented "He don't need to think he's selling tickets to heaven." (June 1921)

When I am late Allie raises cain. When she is behind time she merely turns her clock backwards. (June 1921)

Allie F. tells about never settin' up with a feller later than 10 o'clock as she had everything told to him by that time—lots of times told more than she knowed. Never set up later than 12 with anyone unless it was a corpse. (October 1921)

Allie (*left*) and Molly (*right*) with a guest, who had
heard of Nashville while visiting the artists'
colony at Taos, New Mexico. She came through
Brown County in October 1921.

Allie Ferguson didn't want one of those basted dresses or robes put on her by the undertaker, would rather have one of her clean calico wrappers as she allowed she might want to take a walk around after the resurrection. (November 1921)

Allie Ferguson tells about the old-time gatherings in the wonderful grove on Greasy creek. Said the tables were a block long and groaned under the load. God-a-mercy they were filled when we had "Them gatherings." No, no one ever thought of going out in the fields to take pictures. Wouldn't a picture of one of them gatherings be immense? Mollie added that they were too dern lazy to go out doors and take pictures—stayed in an old tin store up town. One time when the minister was pronouncing the benediction at a gathering a man near the pulpit was swearing at his ox team trying to get them started homewards. (January 1922)

When Elmer King had the smallpox he was quarantined at the home of Ella Taggart, a buxom widow with five children—all sizes. Allie said that the old fool ought to know better than to even think of marrying that woman—a man's as free as a bird. Can put on his hat and step out into the open, and don't even have to put on a hat if he don't want to. (February 1922)

Allie telling about land deal. Two fellows swindled them out of part of land. "It's a long lane that has no turning. One of the fellers is cripplin' around and the other went to hell." (February 1922)

Allie says that Holy Rollers have the real bible all right, but, oh, how they yell. "The Lord ain't def!" (June 1922)

Allie said that no "kikees" can stay at her house—meaning the girls who do not wear the regulation feminine costume. (September 1922)

Allie was asked by several ladies Nov. 5/22 whether they could get dinner there. She saw that one of the two wore knickers and she said: "If that woman had some more clothes on, you could." She generally inquires: "Are those all the clothes you have?"

Mrs. Sam Bradley died Sunday morning, January 21, 1923. Her mother wanted certain songs sung at the funeral. Tressa Bond didn't know them, so Allie got right up and sung them for her—an aged woman.

Checker Winchester has been courting Mrs. Percifield and lately they have been hieing themselves to the old Winchester log cabin to spark on the front porch. Allie, a sister-in-law of Checker's says that he is very much afraid of spooks, ghosts, etc., and as she is wanting to break up the match offered me a week's board if I would scratch on the screen door to make Checker believe there were ghosts in the house—his wife having died there. Up to date I have not considered the matter very seriously—June 13, 1923.

Allie said that a meeting of the merchants brought out the fact that there were few supporters of women's rights here. One man said he wouldn't ship with the railroads. Allie added: "It was only $600 they needed and if our men folks had got us a wash tub and a few chickens it wouldn't have taken long to raise the money." (October 1923)

Nov. 25/23 Rev. Sweeney, Christian minister from Columbus, with his wife and five others ate at Allie's. When it came to chicken he would only accept one piece. Allie said he ain't no Methodist. Applebutter was his delight. He ordered two gallons from Mrs. Ferguson for next year. He ate so much that I told Allie he'd only have one gallon coming next year. His wife asked about some hired girls. The Aynes girls used to work over there. Mrs. Sweeney was a Miss Irwin, of Columbus. Allie told her there weren't any more girls. If she had to hire one now she'd likely run over her and kill her—Allie being so fast on her feet. Besides, said Allie, by the time they sat on the front porch and powdered their nose she'd have to do all the work.

Allie tells me that she sleeps with a hickory club right next to the side of her bed so that when she is alarmed she jumps out with the stick in her hand. (January 1924)

Allie was telling about some woman "ridin" her—meaning talking about her, so she sent her a fine comb and a cake of soap and told her if she used that she wouldn't have time to talk about her. (February 1924)

One evening Mrs. Genolin and Mrs. Mathis came to ask Allie to go to church as the folks were going to pray for the abolition of the blind tiger then in force. Allie told them no she wouldn't as she wasn't going to wear

The Ferguson House, July 6, 1926.

The Ferguson barn, a mile west of town on the Helmsburg Road. Allie made two trips a day in all weather. This particular day was February 10, 1929.

out her knees for nothing. She believed in prayer but was in favor of visiting the place with a hatchet. But they didn't accept her plans. (February 1924)

Someone gave Allie and Molly tickets for the "Poor Married Man" show at the school house and they occupied the front seats. When asked how they liked it Allie said it was all right only she hated to hear all that good music go to waste. She wanted to clear the seats away and have a dance. They very seldom go unless somebody gives them complimentaries. (March 1924)

Allie and Molly came over to have Allie's picture taken for my Star *article, March 30/24 and Allie had even put on some perfume. Had cut glass diamond earrings and a long white dress, close-fitting, buttoned up the back. It didn't fit very well around the neck so she asked for a pair of shears with which to cut out a strip. She then tucked in the ragged edges. Wanted her to hold her head straight. Molly said: Let her hold it crooked and tighten her jaws—then she'll look natural.*

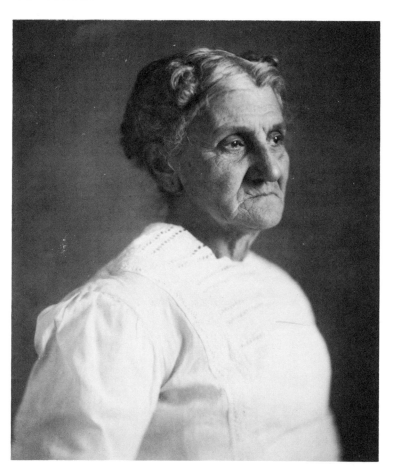

Allie was doting on how long it takes some folks to do something, especially something they ought to do—not be moral cowards, etc. She told me the only difference there was between her and a match was that you had to strike the dern thing before it would go off, but she went off quicker than a wink. (May 1924)

September 30, 1924, Allie was telling me about the visit of two Choctaw Indians, buck and squaw, came from the direction of Columbus, 60 years ago. They were headed for the west. They stopped at Harrison Lucas's place, on the Watten hill, and they invited them for dinner—the family had just completed their meal. The Indians said it was the first time they had sat at a table for many years, always camping by the way. They used good English. Pitched horseshoes and jumped with the Lucas boys. After dinner they went towards the Jackson Branch cemetery, where Allie Ferguson and several others later saw them, on the east bank. He was sleeping and she was sewing. As soon as Allie approached the squaw gave her husband a light touch and [he] woke up instantly. The squaw had long braids and Mr. Taggart, the storekeeper, gave her some red hair ribbon, also some goods to make an apron. The Indians said they were hunting for some hidden treasure—a beech tree with a terrapin cut on it would mark the spot. They went west towards the Moore and Hoover settlements. The Lucas boys bought a handmade gold chain from the Buck. Looked like it had been made from counterfeit coins. Had a budget of blankets and bedding on their backs. No Indians seen here after that time with the exception of those coming from Taylorsville to explore a grave in the Mountain Tea patch country—Bub Henderson tells about it.

Allie says there are more signs than there are hotels in Nashville. "I put my signs in people's stomachs."—Allie says her weapons of defense are a hickory club, hammer and hoe. She was going to chop off Walter Mathis' face. (June 1927)

"Out die me," Allie said when Mrs. Barnes displayed old relics and presents. "I'll want that if you don't outdie me." (April 1929)

Alice Ferguson: Born January 30, 1856, died Oct. 14, 1931 (evening).

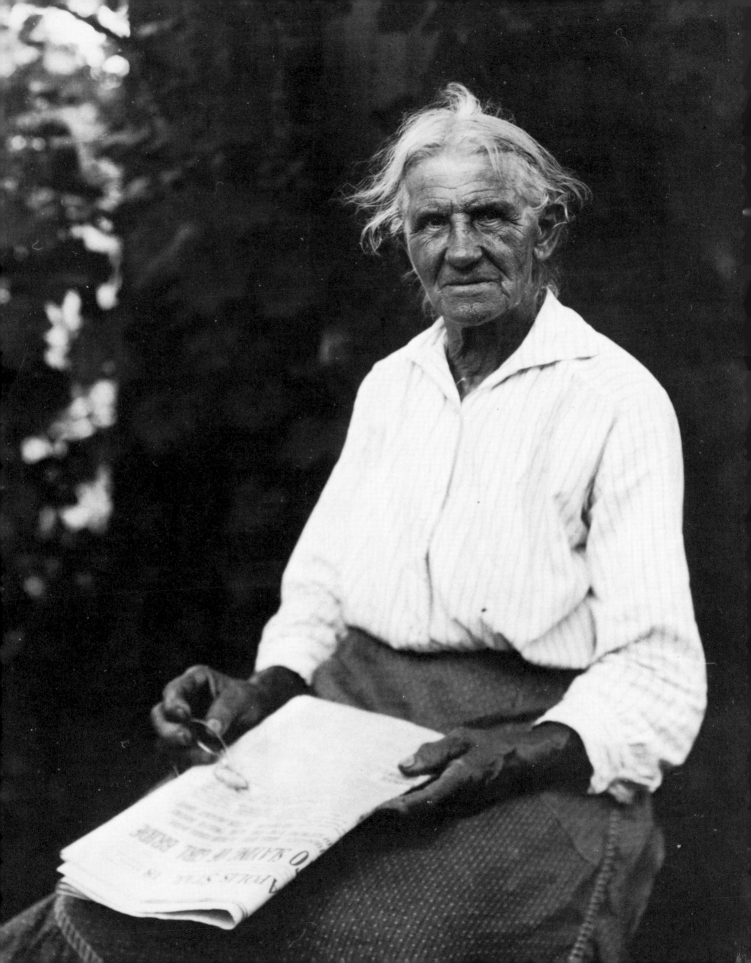

Aunt Molly Lucas

IN MANY WAYS the life of Molly Lucas was similar to that of her younger sister, Allie Ferguson. They grew up on a farm, but both moved to town and took up domestic service trades, Allie as a cook and landlady and Molly as a washwoman. Both women found value in life through pride in hard work and a sense of conservative indignation. They shared a lively interest in community activities and were often called upon for help with births, illnesses, and deaths. Both liked to relax by reading novels and writing letters to female relations. And, as Hohenberger learned, they were equally opinionated and formidable in a witty exchange.

Despite their parallel concerns, the two sisters differed greatly in temperament, Molly being as good-natured as Allie was ill-tempered. Their divergence in basic attitude was so striking that Hohenberger referred to the pair as Sunlight and Shadow. Molly could be critical of society in general and individuals in particular, yet her judgments were usually entertaining. With Hohenberger she carried on a joking relationship involving continuous chiding and teasing. The mutual amusement of their interaction contrasts with the no-nonsense quality of Hohenberger's alliance with Allie Ferguson.

Molly Lucas was six years old when her parents moved to Brown County. To hear her tell the tale, as a farm girl she learned all about hard work and self-reliance. She nurtured a lifelong disappointment in men. Unlike Allie, she never married, and that perhaps helps to explain why she could be more humorous in her antagonism.

Like many so-called spinsters Molly Lucas became a washwoman. Word of her helpful disposition was widespread, and her house was often used as a temporary residence and storage area by families moving into or away from Nashville. As she grew older she came to be known as everyone's aunt, and she bore the subtle stigma of the childless. Other townspeople considered her eccentric because she had such habits as wearing heavy rubber boots in all weather and trundling around Nashville with her wheelbarrow. It was easy for others to see her unwedded independence as another aspect of her eccentricity, rather than as a respectable and calculated choice. Thus she was marked as a town character, well liked and well used but not taken completely seriously.

In their later years both Molly and Allie became increasingly dependent on the business of "furriners," first the artists and then the tourists. In general they got along all right with the artists, who were also individualists and social misfits, but they were mightily irritated by the tourists, with their obtrusive

55

Molly Lucas reading the *Indianapolis Star* in the back yard of the Ferguson House, summer 1923.

fashions and patronizing questions. It hurt the sisters' pride to serve such people, and their brusque manners and inflexible house rules were, in part, an attempt to retain control and maintain their self-respect.

Molly Lucas and Allie Ferguson witnessed the transformation of Brown County, and they were among the few who regretted the changes even while taking part in them. It was difficult to resist the changes because what was gained was direct, immediate, and of a different order than what was unpredictably lost. Ironically, the whole process began close to home. The log house their father had built on the family homestead in Jackson Branch Holler was the first one near Nashville to be bought and remodeled as a rustic retreat by an outsider. Fred Hetherington, the Indianapolis industrialist who took over the property, soon surrounded himself with aristocratic associates, renamed the valley Whippoorwill Hollow, declared the road a private lane, and locked out the public.

During the 1920s Molly Lucas lived out of a sleeping room at the Ferguson House, her own home being by this time entirely full of other people's possessions. She was kept busy with the menial chores of the boarding house, in addition to her regular laundry service. Like everyone else she was somewhat intimidated by Allie Ferguson and tended to defer to her gloomy and domineering sister. Yet she remained true to herself, and through the influence of her skeptical but persistent optimism the shade about the place indeed seemed to be dappled with light.

Mollie Lucas' birthday December 5, 1918. Her 69th. Stopped horse in middle of road as I was coming from Jackson Branch with ice for Pop. Dec. 2 1918. She went to Bicknell to wait on Joanna, who died there of the Flu.

When asked where she got that long cat lying under the stove Mollie Lucas said: "Good laws, we growed him." Her sister was a real hunter. One day a "hock" was flying over the place and her sister got the gun, pulled the trigger. She thought the bullet was a long one—afterwards found the ramrod was missing. (November 1919)

Molly Lucas said she and Allie received a box of candy from Miss Mann for Xmas. They both ate all of it at once for fear some one would call and they'd have to be hospitable. (December 1919)

Molly Lucas, April 14/20 came after my clothes for pressing. She said: "As soon as I can find a man the size of these clothes, I'm gone."

56

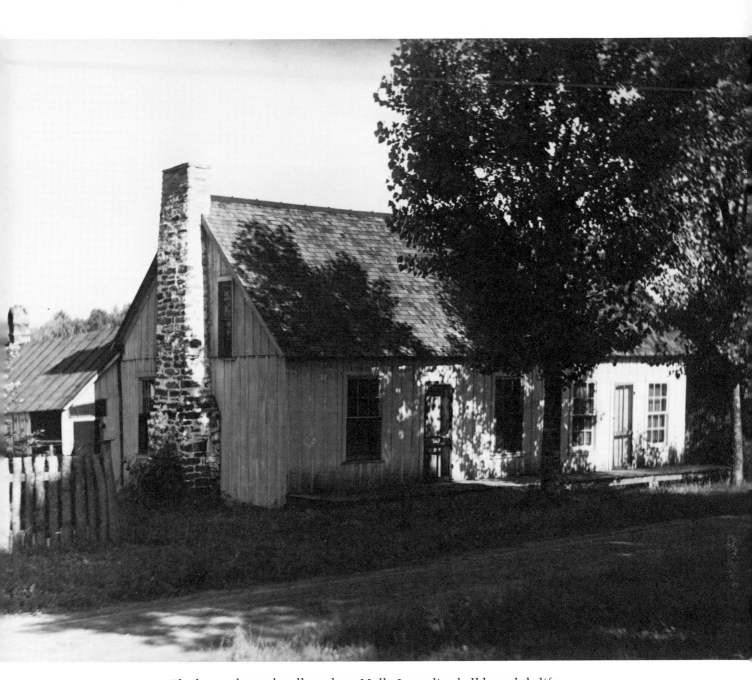

The house down the alley where Molly Lucas lived all her adult life.

Talking to Molly Lucas about having time to die, she said: "If I do die I'll get shed of being sassed by you." (July 1920)

Molly Lucas said she was 71 and did as she durned pleased. (November 1920)

Mollie, Dec. 28/20 was busy all day cutting up a hog—this being a general butchering day in Nashville—and said she thought she had earned her dinner. She told about the one fellow who had wanted to marry her—I think he was from Columbus, Saunders by name. He was unsuccessful because as Mollie said "I didn't want a man who was always foolin' with old flowers"—he was a greenhouse owner.

Mollie said she'd repair my old trousers so nicely that I'd want to wear them to church. (May 1921)

When I took a pair of trousers over to her to be washed Mollie said, just as I was leaving the place: "No wonder you never have any money—these holes in your pockets are agin' yuh." (May 1921)

Mollie was in a hurry as usual one evening and I asked her the cause for all the rush. Said Allie started a letter to Mirtie and had to go a-milkin' so she had to finish the letter for the evening mail. (May 1921)

Mollie Lucas said she was reading "Holding a Husband" in the **Indianapolis Star** *and didn't want to miss an issue. I teased her about getting married at the age of 70 and she said if she had a husband she sure would hold him. (May 1921)*

Josh Bond has some photos of tombstones in his display window and I suggested to Mollie that now was a good time to pick out a stone. Her reply: "Well now, say, all I want is a rock at my head." (June 1921)

Allie and Molly arguing about a certain party married a number of times. "Dern her old soul, she had the same hat and shoes when she was married the other time," said Allie. "Maybe she liked them real well," answered Molly. (June 1922)

Mollie Lucas had been on a visit to the city. I said to her. "I understand that you got all swelled up on yourself since your trip to Indianapolis." "Well,

58

even if I did visit rich folks, it didn't rub off on me!" she replied. (November 1922)

I have noticed that a good many of the native women after marriage walk along with their husbands as though they were slaves—even afraid to raise their eyes in anticipation of a greeting to a perchance male member of the species. One is impressed with the jollity of the non-married. (April 1923)

Mollie and Allie sat up the other evening way into the night, all of 8:30, to count up the population and in their research work they found 25 widows and grasswidows, 8 widowers and 5 old maids. (May 1923)

Mollie knew how old she was but couldn't tell the year she was born; said [it] was written down somewhere and she wasn't wrangling her brain about that. Was born in Belmont county, Ohio, near a little village called Dogtown. (May 1923)

Aunt Molly built a bridge all by herself across the little brook that flows through Allie's yard. Said it didn't cost the county a cent and there was no toll. (September 1923)

Aunt Molly said she wouldn't vote. The men folks got the country in the shape it is and now they want to wash it off on to us. (February 1924)

Aunt Molly said she liked the dog Allie got from Mary Vawter until one day she saw him sitting on a box and [it] looked like Ike Shipley—then she grew tired of him right away. (February 1924)

A man was ekeing out a mere existence and Molly referred to the incident like this "He can't live off the chips from a whetstone." (February 1924)

I asked Aunt Molly about marrying and she said she didn't have enough money to keep a man like she wanted to. Besides, the hot weather, dirt and weeds are keeping her busy. (June 1924)

Molly said she was too tired to even tell the truth. (June 1924)

Allie left for Illinois on the morning of October 16, 1924, all dolled up in a linen duster. She gave Molly orders to not take any boarders while she was

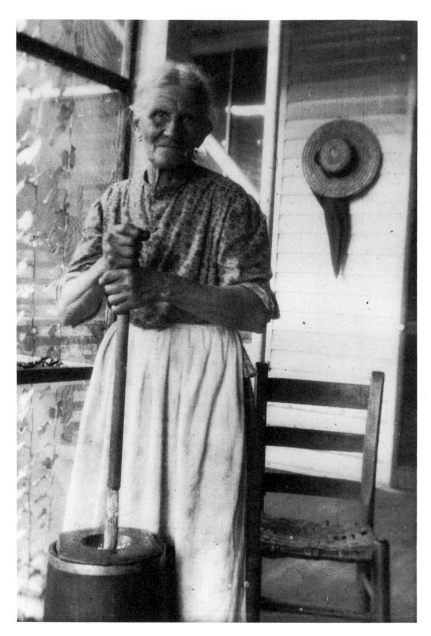

Churning butter, 1918 or 1919.

gone and that she didn't know when she would come back. Meaning that she would slip in unbeknownst. Mollie said Allie always found things in good shape at that. She cautioned Fay Webester to not go to bed leaving Molly reading near a lamp as she would fall asleep and upset the lamp, setting the house on fire. Molly said when she got ready to go to bed she'd sit on the landing and wait for Fay to get sleepy. She also was cautioned to not pour any coal oil in the stove on live coals. Molly began to apologize about the dinner. Said she made the sausage cakes large but that they had all drawn up. The potatoes were prepared according to Fay's style and she reckoned I wouldn't care. She didn't know whether the coffee was strong enough or not. The pie she had purchased from a woman who is running an eating place on the side. Molly said we wouldn't have to eat that kind of pie tomorrow.

Aunt Molly cleaned her side of the alley immaculately clean and then told Bartley to get after his and for him not to throw the weeds on her side. He said he would when he got to feelin' better. Molly said she'd take a cheer and do the work or have a bed hauled out afore she'd let anyone outdo her. (July 1926)

Aunt Molly is a week behind in reading "Little Benny," etc., because the canning business is heavy. Allie has been rawhiding her for reading the stuff. Allie can get meals easily as Molly does the circular work, runs up and down cellar steps for butter, cream, draws a bucket of water from the well, etc. (July 1927)

Aunt Molly sick. Folks couldn't believe it—hasn't been ill for 35 years. Couldn't see how she would have time to get sick. Molly was 78 December 5, 1927. . . . Dr. keeps Aunt Molly in bed so neighbors can visit her—always on the go. Molly said she was gittin' better in spots. . . . Aunt Molly was sent to Indpls to do some work for Allie, her sister. While there, Molly contracted a very bad cold, and she said "Now, that they've got me down they kin git me up."

Molly didn't want any flowers on her grave, at least not more'n a Jimpson weed. (November 1928)

Talking about Zepplin, Molly said, "I wonder where they're gonna put all that trash when the end of the world comes?" "Jist 'cause Noah put 'em in the ark two at a time is no sign they're gonna pile work up on me," said Molly. (October 1928)

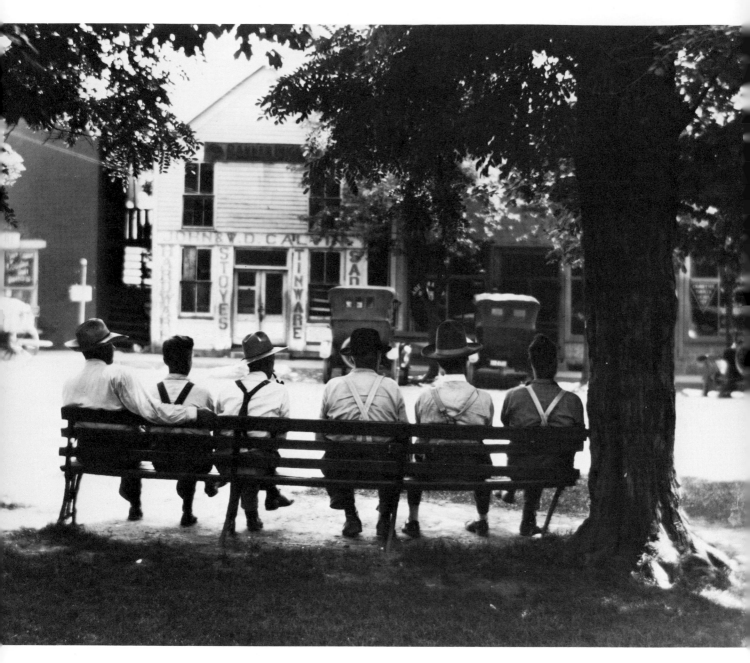

The photograph that created the Liars' Bench in 1923 and intensified Nashville's notoriety. Hohenberger sold hundreds of prints by mail order, and the requests continued through the Depression. Although tourists viewed the bench as a symbol of small-town unity and equality, all the men pictured here were members of the ruling circle in the Democratic party. From left: Scott Moser, County Auditor; the young Jack Woods; Bub Henderson, County Clerk; Sam Anthony, a farmer; Harry Kelp, Justice of the Peace; Duard Calvin, a farmer.

Harry Kelp

BEYOND THE FERGUSON HOUSE there were several places around Nashville that Hohenberger frequented in search of traditional lore and current news, among them the courthouse, the post office, the *Democrat* office, and T. D. Calvin's general store. But perhaps his favorite place was Harry Kelp's barber shop. Kelp was not known as a great barber, being generally considered slow and dangerous. But he was a central figure in the town's political structure, and his shop was usually crowded with men, most of whom were not waiting for a shave or a haircut.

Harry Kelp was about the same age as Hohenberger, having been born in 1877; like Hohenberger, he lived into his late 80s. He grew up about three miles northwest of town, in a house that had been a stagecoach stop on the Old Helmsburg Road. His parents had emigrated from Germany to Terre Haute, and then to Nashville. His father was a cobbler and wanted his son to follow the trade. But the young Harry Kelp was always running off to the city. First he went to Indianapolis to take singing lessons. He came back to Brown County and lived in a one-room cabin, hewing out ties for the new railroad line. Then he returned to Indianapolis to attend barber college. Back in Nashville he bought a barber shop, paying the previous owner five dollars a week for three months. Once established, he left for Chicago to study law. He soon came back to his barber shop, then returned to Chicago to study theology.

Harry Kelp never realized his ambition of becoming a preacher or a lawyer, but he was elected Justice of the Peace, and by the time Hohenberger met him he was known as Squire Kelp. In fair weather, when he was caught up on customers, he could be found across the street on the Liars' Bench. He was passionately attached to that bench, a feeling shared by other men in his social circle. Hohenberger noted on page 363:

> Ike Shipley came to town about 2 p.m., October 10, 1924. He was silhouetted against the western sky and you couldn't tell who it was for sure until he pulled up the alley on the east of the court house. He was being towed in by a team of mules hitched up to a worn out topless surrey. Lee Bright said here's a whole afternoon's entertainment. The dogs in the court house yard welcomed him and when Ike alighted to tie the mules to the chain hitch rack the first thing he did was to kill the assembly of nit flies on the mules' legs. Then he grabbed his lard pail and made a straight line for the lone vacant seat on the Liars' Bench.

Actually there are very few passages in these notes concerning the entertainments on the Liars' Bench because Hohenberger was not particularly welcome to join in. But his newspaper columns are full of reconstructed incidents, which he heard about indirectly from Harry Kelp. The main art form practiced on the bench was, of course, the lie or tall tale. The following example was printed in "From Down in the Hills O' Brown County" on January 22, 1927:

Uncle Mart was telling the Liars' Bench crowd that when he backed up Sherman on his fightin' trip to the sea they had the largest cannons in the world bringing up the rear.

Sorg Matthis didn't think they were larger than the ones that trailed him around "Chickymawgee," and invited an illustration as to size.

"Sorg," said Uncle Mart, "them cannons wuz s' dern big that it tuck two team o' oxen t' pull th' ball t' its place."

"Well, how'd th' animals git out?" asked Sorg.

Uncle Mart was rather astonished at such remark and before the crowd broke up said, "W'y through t' totch hole, yuh idiot."

The humor could also arise from cleverness in teasing, as in this item printed in the column for July 11, 1925:

The topic for discussion in the neighborhood of the Liars' Bench was "Whose all our villages named after?" and one of the natives claimed "they were all named before us." Then the question had to be rearranged and all agreed on "In whose honor are they named?" After the stage was set Jim Reddin showed up and he told how Nashville, Helmsburg, Trevlac, Elkinsville and Georgetown got their names, and was about ready to leave when someone asked him whether one of the villages wasn't named for him.

"Well, not that I know of," said Jim.

"I've heard of it a number of times," said the native.

Jim swallowed the bait, trap and all, when he asked, "What is it?"

"Stone Head," greeted his ears, supplemented with a chorus of lusty yells from the crowd that was growing heavier and heavier.

Sometimes the men on the bench indulged in word play for its own sake, as in this case from September 16, 1923:

The Liars' bench is fast coming into prominence—no one seems to have a desire to avoid it. Prohibition and profanity have been discussed for days and a new topic was despaired of until Harry Kelp brought up the tobacco question. He was seated facing his barber shop listening for a job. With eyes cast downward, he discovered a cigar butt less than an inch long, and he asked that other occupants of the bench surround the same while he asked a question. A semicircle was formed and then Harry inquired: "Did the owner smoke the cigar long or short?"

Hohenberger was well aware that while the men sat on their bench lying about the Civil War, or reviewing county history, or discussing cigar butts, certain women around town were becoming increasingly dissatisfied. As their anger grew during 1928 and 1929 Hohenberger recreated many exchanges, like this one included in the October 21, 1928 copy of "From Down in the Hills O' Brown County":

> A woman, looking for some help to rid her garden of weeds, made a trip uptown. She sized up the liars' bench crowd, everyone of whom was too busy to rake in a few shekels. As she left the scene she met Lizzie Thickstun.
> "I hope they git s' dern hungry they'll have t' go t' work," she told Lizzie.
> "Ef their 'lowances frum their city relatives would quit comin' in they'd git s' derned weak they couldn't work an' then I guess we'd have to cut their weeds an' feed 'em, too," said Lizzie as she shifted a clothes basket to the other shoulder.

Harry Kelp never married. Even though he presided over the daily gatherings at the bench in the courthouse yard, he didn't have to face a resentful wife. Occasionally he was exhorted to make more of his life by his younger sister, Olive, also unmarried, who was rising to prominence at the Nashville State Bank. Harry shared a house with Olive and their invalid mother. As long as his friends tolerated his haircuts he could get by as a barber, play politics, fiddle and sing for his own enjoyment, and sit on the bench and watch the world go by. Hohenberger admired Harry Kelp for his personal values, and Kelp got along well with this odd intruder from the city. Among the men of Nashville, Kelp was the closest thing to a friend that Hohenberger ever had.

Harry Kelp said he was reading book "Around the World for Sixty Dollars." He told some one about it and they said Bill Hoy could go around for 60 cents. Two fellows telling big tales in barber shop and after they left Harry said the first liar hadn't a chance. (March 1919)

It was a cold evening, boys were coming from postoffice and complained about no place to go to get out of cold, when Paul Percifield spied a customer in Kelp's barber shop. "Don't worry, boys, Kelp's got a man down." It takes Harry from 30 minutes up to shave a fellow and they figured on a loafing place until he did the work. (January 1920)

July 6/20. Harry Kelp was all dolled up in front of shop—hat on and all. I asked if he would shave me. Said he guessed he wasn't too nervous. When I got in the chair the talk drifted to "signs." Mrs. Winchester said that inasmuch as he looked like his mother he would be rich. If a daughter

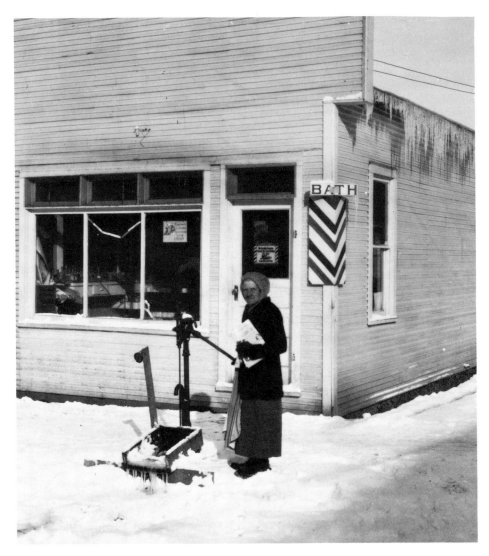

Molly Lucas in front of Kelp's barber shop,
January 22, 1926.

looked like her father she would be rich. He said that Ann's sister always put a quarter under a churn to make the butter gather faster. Also that Mrs. Pittman insisted that Jim Kennedy's grave be dug and covered under canvas for if water got in it it meant another death in family soon. Said that little Betty's grave had water in it and of course inasmuch as Jim was a relative he was the one that fulfilled the old prophecy. If a grave caves in soon after the burial it means another family death soon.

Harry Kelp said John Yoder was in his shop July 13/20 to get his haircut. Said he was always told getting hair cut in dark of moon would prevent its growing fast. What would the poor barber do in the light of the moon? No way to prove some of these superstitious things. If a buzzard flys over house it predicts death in family. Man said he wouldn't live in 13-room house for anything. No doubt that accounts for the fact why so many large families live in small houses.

Harry Kelp keeps right on with his slow speed. Some one said that inasmuch as we have lots of time here we don't mind going back the next day to have him finish cutting our hair. T. D. Calvin was going to get shaved and asked his wife if she would wait at the store for him. When told that there might be several ahead of him his wife asked for the keys to the house and went home. About an hour later T. D. arrived. She said: "You must have had a big string ahead of you." Another evidence that you can get in bad with your wife—and it is all the fault of this simple slow life. (December 1920)

Harry Kelp said the closest call he ever had to getting married was when he was best man at a wedding where a cross-eyed preacher operated. Looked at him all the time, seemed like. (August 1923)

Harry Kelp, the barber, said he made a mistake when he took up law here. The land is so poor folks can't even raise a racket on it. (August 1924)

Oct. 5, 1924. I was sitting in front of Kelp's old shop and there was room on the bench for a few more. Along came two furrin girls and a fellow. The girls were getting weak-kneed from walking but the fellow cautioned them to not sit down as folks would think they were natives.

Harry Kelp, when asked what he was doing now said he worked during the week, went to church on Sunday and stole uv a night. (October 1924)

Harry Kelp in cutting Charley King's hair said it wouldn't have to be a very good job as Charley always wore his hat over his ears. (November 1924)

Lon Kennedy says in barber shop the new way to make liquor and dodge the revnooers is to take a pumpkin, cut out the top and then remove the fillings. Insert two-thirds sugar and one-third water, and let set after you put the top back on. They say when it begins to ferment that it can't be beat for real liquor. Pumpkins will be scarcer for Hallow 'en. (November 1925)

Saw Harry Kelp shaving Chris Brummitt with clippers Nov. 9/25.

Harry Kelp said he would like to get married but felt he might land one of those paper bag and tin can women. (November 1925)

Harry Kelp closed up shop when a man asked for hot water to start car. It took all they had so Harry announced to the force that they would go to supper while the next supply got hot. (December 1925)

It is quite noticeable that the style of language [in the barber shop] has moderated a great deal since hair bobbing came in style. (December 1925)

After taking his picture shaving himself Harry Kelp says his motto is: "We know our work is right—we use it ourselves." (January 1926)

Harry Kelp was nominated for Justice of the Peace and folks said they 'lowed Harry would favor the fishermen—if he didn't he would find a bundle of switches at his door. He said he didn't care if they were laid there in the winter time. (May 1926)

Harry Kelp had "Drink More Water" sign in his barber shop window and when his helper, Lon Kennedy, got arrested for owning a still Harry said, "I always told him to drink more water." (June 1927)

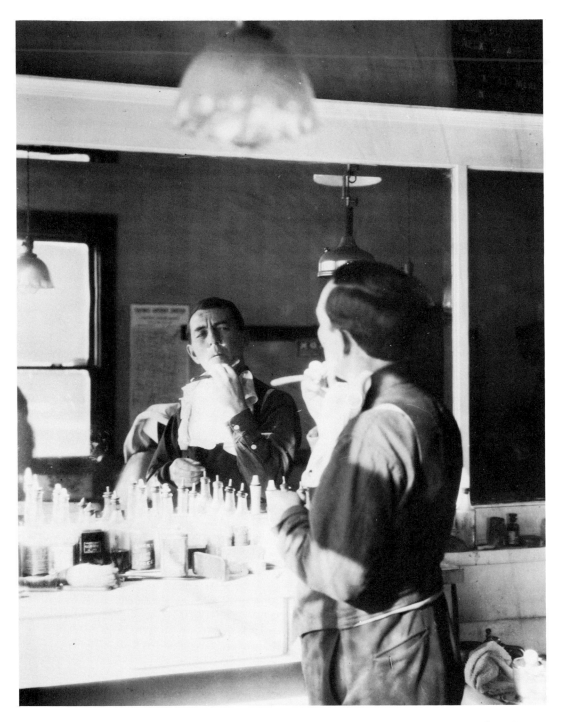

"We know our work is right; we use it ourselves."
January 22, 1926.

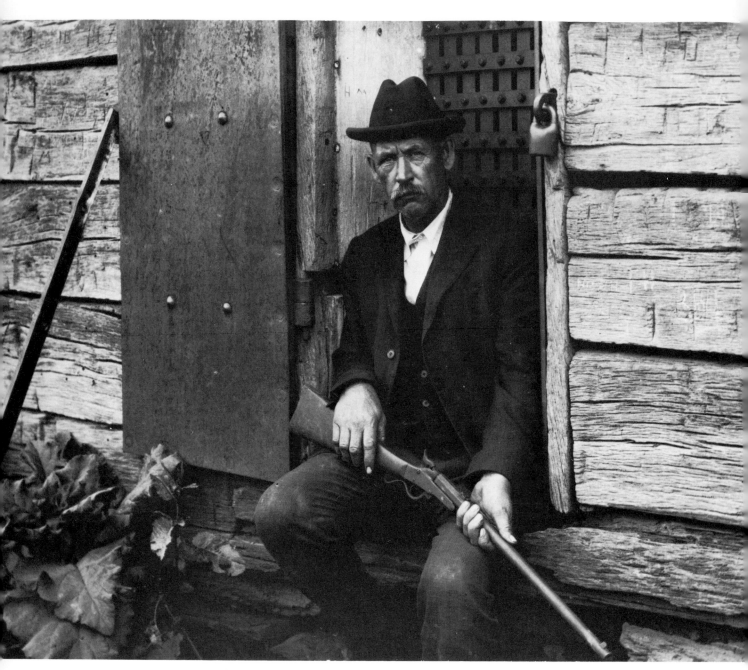

Sam Parks in 1925, shortly after he leased the old log jail from the County Commissioners.

Sam Parks

EARLY IN LIFE Sam Parks lost interest in farm work. Although he took over the family farm at the age of eighteen and later married Ida Hedrick, who would inherit her parents' farm, he was often preoccupied with other plans for making a living. For some years he worked as a policeman in Bloomington. Then, when he was 31, he nominated himself in the primaries of the Democratic party for Sheriff of Brown County.

Of the county government offices at the turn of the century, those of Prosecutor, Auditor, Coroner, and Surveyor required special training. To be Recorder or Clerk required proficiency at paperwork and good handwriting. Candidates for County Commissioner usually had some prior prestige in the community. To be Sheriff, however, required only the ability to carry out the routine tasks of the court and the nerve and muscle to intervene occasionally in drunken brawls. Property crimes in rural areas such as Brown County were almost unknown, but the local Sheriff did have to maintain the fine line between disorderly conduct and manslaughter. As the one official who mediated directly between social norms and antisocial behavior, the County Sheriff was permitted, even expected, to be equally familiar with both extremes. In return for his services, the Sheriff was granted a small salary and expense account, a house to live in, some discretionary power, and special favor with the civic and business leaders of the county seat. It was not uncommon for men with questionable attributes to seek the nomination and to win a race over more idealistic, authoritarian candidates.

Sam Parks was endowed with a good combination of questionable attributes—he was too fond of whiskey; he liked to gamble; he was rowdy, impudent, and cynical. He was elected Sheriff of Brown County in 1902 and again in 1904. During his two terms of office no further opportunities presented themselves, in or out of politics, and in 1906 he reluctantly returned to the farm. Running for Sheriff had been his best chance, but his success was not enough to get him permanently out from behind a mule. Nashville was simply too uneventful. Hohenberger often heard it said that when Dennis Calvin had been Sheriff, from 1910 to 1914, he spent all his time tending his flower beds around the courthouse square.

This situation began to change in the years following World War I, when the county was presented with several worsening problems. Attempts to mechanize farming to keep pace with adjacent regions of flat, fertile land were proving disastrous for many farmers. Hundreds of families in the hilly areas, unable to

raise enough cash for mortgage and tax payments, were selling or abandoning their farms and moving out. The nostalgia focused on Brown County by the artists, combined with improved highways and the popularity of the automobile, created regular traffic jams at Nashville's one intersection and uncounted accidents on the back roads. Increasing numbers of outsiders were building summer homes and weekend cottages in the countryside, and there was a gradual upsurge of burglaries and vandalism. The Ku Klux Klan was intensifying its moralistic terrorism even though adverse publicity was making such clandestine social control officially less acceptable.

All these problems cried out for an active and conscientious Sheriff, but the seriousness of the trends was muffled for a time by the furor over Prohibition. The strength of the appeal of strict temperance in Brown County may be judged by the fact that when the Prohibition party ran a candidate for Sheriff in 1904, he received 56 votes, as compared with 1,091 for Parks and 786 for Parks's Republican opponent. The faction made another effort in 1906, did no better, and never again tried its luck in the local Sheriff's race.

After the eventual passage of the Volstead Act, politicians in Brown County, as everywhere in the United States, were expected to find a compromise between national policy and local values. In many localities the opinions of the people were not consistent, but in Brown County the voters, including the newly enfranchised women, seem to have neared a consensus. Abusive or violent drunkenness was against the rules, as had always been true. There was nothing overwhelmingly wrong with drinking liquor, however, and most men were soon acquainted with illicit corn whiskey, known as "white mule." Most women were less enthusiastic about liquor, but they tended to tolerate the drinking habits of the men and tried to keep their particular men out of trouble. Several women spoke out in favor of temperance, along with a few educators and clergymen, although in Brown County some male school teachers made white mule and some ministers drank it.

The Sheriff during the transitional terms between 1918 and 1922 was the incorruptible Clint Moore. By 1922 most voters of both parties were ready for a less-conscientious candidate and hopeful that he would reinterpret the law to their benefit as well as his own. When Sam Parks announced that he would run for Sheriff, some concerned citizens, remembering how lax he had been twenty years earlier, circulated a petition to ban him from the election. Anonymous letters to the County Commissioners warned of awful consequences if he won the race. Parks was elected Sheriff, and the night after he moved into the Sheriff's house in Nashville it burned to the ground. The Commissioners rented Parks and his wife another house, and he took office determined to take full advantage of the confusion and conflict that pervaded Nashville.

During his first term of office Sam Parks irritated many persons, but others

The house near Elkinsville where Parks lived until he moved to town in 1922. Parks's wife, Ida, inherited this farm, which she refused to deed to Sam because she knew he would sell it. Ida eventually gave it to her sister on condition that she care for their ailing mother.

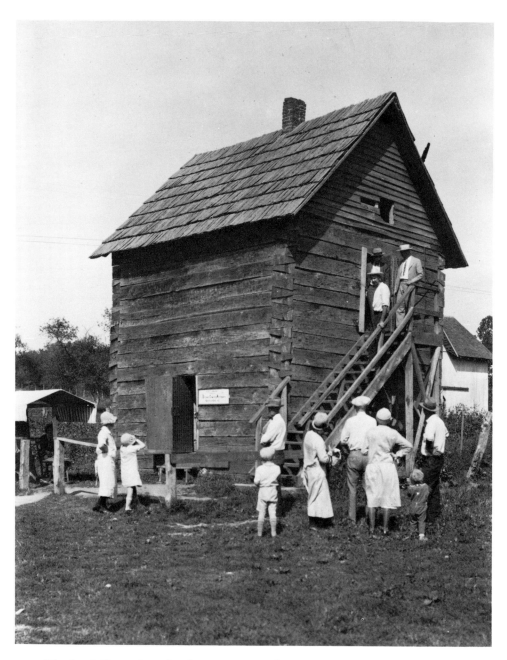

The log jail continued to be a museum after Sam
Parks lost his lease. Ironically, the lease was
granted to Mr. Montz, his new landlord. This
photograph shows tourists in September 1927.

were pleased with his half-hearted and selective efforts at controlling illegal activities in Brown County and willingly paid him some extra income. It was said that the only gamblers and distillers raided by Parks were those who happened to be officers in the local committee of the Republican party. Twelve candidates for Sheriff entered the primary campaign in 1924, and the race was especially heated for two reasons: First, it was obvious to everyone how profitable being Sheriff could be. Second, the County Commissioners were planning a new jail and Sheriff's residence to replace the old log jail (which had been condemned by the state for years) and the Sheriff's house (which had burned). The new Sheriff would be the first person in Nashville to live in a home with all modern conveniences. Parks had to make a deal with the Klan to ensure his reelection.

Parks was the first native of Brown County to realize the profits to be made by encouraging the increasing numbers of sightseers, and despite hostile petitions he went ahead with a scheme to convert the obsolete log jail into a museum of pioneer relics and other sensational curiosities such as whiskey stills and rattlesnakes. Within two years he had taken in $1,200 in dimes. Shortly after the museum opened, Hohenberger posed Parks sitting on the door sill, holding an antique shotgun from the display.

The other residents of Nashville opposed the adaptive reuse of the log jail because they didn't like their reputation as simple rustic folks, and because they didn't wish their county seat to become a tourist attraction. They resented Parks not only because he had created an innovative sideline for himself, but also because they felt that Parks's museum was demeaning and would not serve the long-term interests of the county. Parks's critics were largely unaware of another activity that not only had a greater impact on the future of Brown County but also made Parks much more money. Richard Lieber, in the guise of the Indiana Department of Conservation, decided to create a wildlife preserve on Weed Patch Hill with the intention of later establishing a new state park. Sam Parks, along with a few local lawyers and real estate agents, was involved in securing options on the desired land. Parks was very resourceful at this task. He shared in sales commissions from the state and also took the opportunity to engage in land speculation himself.

After Parks was reelected in 1924, he was less cautious in the pursuit of his own advantage. He began to harass the less influential moonshiners and to deal more openly in confiscated liquor. His personal behavior also became more licentious as he freely indulged his drinking habit. Finally, in October 1925 he was arrested by Joshua Bond, the County Coroner, and charged with public intoxication after creating a disturbance at a fox meet. A month later, while delivering a prisoner to the Monroe County jail, he was arrested by Bloomington police and charged with public intoxication and transportation of liquor.

As he had joked with Hohenberger about what he would do if he were ever caught, Parks claimed that the whiskey in his car was from a recent raid on an illegal still and that he had somehow forgotten to dispose of it. He succeeded in getting the charges reduced, but his career in public service was finished. The Democrats shunned him, Richard Lieber would no longer employ him, and his wife left him. Parks delayed his trials until after his term of office expired in 1927. Then he rented an apartment in the first apartment building in Nashville, and prepared for his divorce proceedings and his drunkenness defense. After spending most of his money in these losing causes, Parks took a job selling used cars at the new Ford garage.

Not long after he started working at the garage, Sam Parks told a story to the idlers in the back room; Frank Hohenberger recorded it in his notebook and later used it for his column in the *Indianapolis Star.* Parks described how, as a penniless farm boy, he had been hired by a neighboring farmer to help drive some cattle to market. Thus he discovered the intriguing quality of cash money. This memory reveals the forming of a desire that moved Parks to cooperate in the transformation of Brown County. He sold his birthright, and when possible those of his neighbors, in favor of a more alluring way of life. The desperateness of his ambition, which was at the same time both aggressive and fatalistic, marks him as the first recognizably modern character to emerge in Nashville after the First World War.

Sam Parks approached a woman and asked her to vote for him. She was of a very religious turn of mind and since Grover David, of Nashville, was a candidate for sheriff also she said that the bible spoke of David and she would have to vote for him. Sam gave her some references to show that Samuel was mentioned in the good book also, and she was delving into the same when he left her. (May 1922)

When Sam Parks ran for sheriff the last time he offered as an inducement for folks to vote for him that if they would help him out he would pay them what he owed them. (May 1923)

Sam Parks was telling about getting lickered up on Red Bitters and going to a Pentecost meetin'. He said "Now brothers, how do you explain this scripture 'Blessed is he that expecteth nothing for he shall not be disappointed'?" Harry Kelp chimed in with "That must refer to folks wanting to join the Campbellite church." (January 1924)

76

Blufe Reddick got soused, entered Rustic Parlor, pushed Orv Pittman against hot stove, upset it down to the floor frame and there was a hot bowl of coals exposed. Sam Parks grabbed him and then Blufe made a lunge for Grover Pittman, almost tearing his clothes off of him. Finally Dennis Calvin helped and Parks had a heel under each arm and Dennis was at the head under the shoulders. They took him over to the jail for sobering up. A few days later Blufe explained that he went to the jail on an inspection tour as he was going to run for sheriff. (February 1924)

Commissioners met and someone said that the boys were shooting craps in the court room. Clint Moore thought the sheriff ought to arrest them. John West the commissioner said that the sheriff was playing with them. Also was accused of breaking open a gaming machine in the courtroom. Sam says—"Don't write it up now—wait a little." I think he is running for sheriff again. Wants to avoid any publicity. (February 1924)

Some one said the sheriff was as blind as the tiger when it came to making arrests. Clint Moore was telling he knew just about for sure who was making liquor around here—pointed out one fellow who was dressed pretty well and was eating oranges and candy. Clint said you knew when a fellow ain't working he can't afford those things. (March 1924)

April 25/24 in the postoffice Sam Parks was asked what he was paying for votes and he said three dollars. Just then the Methodist preacher had business on the outside with Sam—but it wasn't political talk, it is said.

Sunday evening, January 4, 1925, Clarence Long, John Allison and Wilbur Sims were in Rev. Meadows office drunk. The preacher had been to Endeavor meeting and came back to get a book, when he discovered that the men had entered his place and built a fire. The Rev. called the sheriff to empty the place and Sims got loud in his talk. Thereupon the Rev. said if the sheriff didn't empty the place he would and then grabbed a chair. The sheriff took Allison and Sims to Sims place and while in the back room Sims struck Allison, and when Allison got up he said he couldn't understand that as he thought they were friends. On the way to the store John told Parks that if he took Sims to jail he'd have to take him, too. The next day Sam Parks said he picked up some eyeball edges and several yards of skin at Sims store. Wanted to give them to Allison. A customer who went to the Sims store

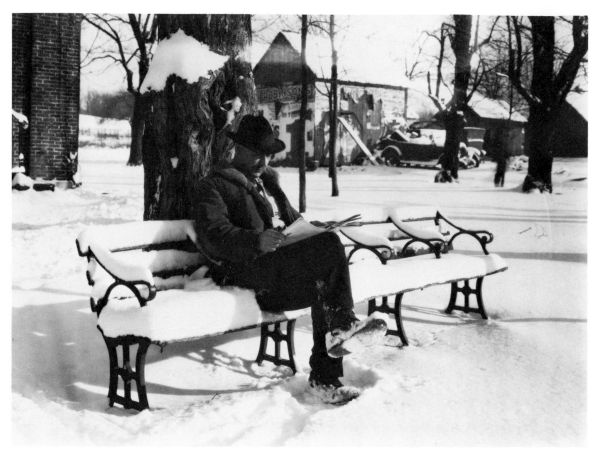

Sam Parks on the Liars' Bench, January 22, 1926.

asked for Wilbur and his wife said he had gone out for some fresh air. She was so glad as he needed a rest. Just about that time he was indulging in liquor. I told the Rev. we were going to get some special labels for his liquor and put on them "Made in the Meadows of Brown county." It was rumored that the trio had gotten hold of the communion wine. The Rev. said he didn't know about that but thought the crowd should have offered him a drink. T. D. Calvin commenting on the affair said the town now was more like a Sunday school than it used to be. A man would ride down town through the main street and brandishing a knife, with gun in boot, would yell out "Bring out your damned marshal—what kin he do?"

It is said the Klan shifted its support at the last minute in the 1924 election. Mrs. Thurle Allison and Mrs. Clark were both out for recorder and it was a close race. When Sam Parks came out for the second term things looked shaky for him. Then the Klan got busy. Over in Van Buren they agreed to vote for Sam if the Nashville crowd would vote for Mrs. Clark, and the deed was done. Parks and Clark elected, or rather nominated, which is equivalent to election. (February 1925)

Sam Parks said if he had $4,000 he'd show the county what a real sheriff was, meaning that he'd have to have that much to live on as he knew he'd never be elected again if he did his duty. (April 1925)

Friday, April 3, 1925, about 3 p.m., I accompanied Sam Parks, sheriff, on trip to E. L. Miller's, south of town, to see about the deal the state has on with him for game preserve land. We stopped at the top of the hill to examine the new hotel, also one of the cabins, and while I was making a survey Sam stirred up the leaves to pull out a fruit jar. On the way over we picked up Jim Mullis, brother of Alex, who was on his way to Schooner valley. Sam asked him about liquor and Jim said he hadn't seen any. "Suppose you drank it after night," said Sam. "I ain't larned it yet," meaning the process of distilling, Jim said. "I hear a heap o'tales, but I'm afeared of it. It might kill a feller. Never did hunt after it or inquire about it. Years since I left that holler. Am workin' at everything—first one thing an' then another." "You aren't full of mule, are yuh?" When we got at the foot of Schooner hill Jim asked Sam to stop as soon as he could, and if he did Jim would walk back. Sam couldn't stop until we were near the bridge that crosses the branch from Rufe Reddick's. Sam said he never did take an interest in farming. Every time he put himself between the plow handles he was thinking of something else. He began at 14. Always wanted to be a sheriff. The view from the ridge rims were fine, Sam thought, but George Mannfeld didn't. After an all-around drink the scenery looked better. I could hardly see the view as I was obliged to watch Sam's driving. He sure drove on the rims of the ridges. Took an extra slug before we started down the hill to "Grover's." We looked through the supposed timber of Mr. Miller's and found all the oak had been cut. The beeches were valuable, Sam said, as the state would want a lot of squirrel holes—the trees were pretty rotten. Sam said if anyone arrested us we'd have to explain that he forgot to take some mule out of the car when he jerked a fellow the night before. When Sam talks about arrests he says: "So called."

When Sam Parks put over a big real estate deal it hurt a lot of people, including the banker. (June 1925)

Od Harden escaped from Sheriff Parks about 7 a.m., Sept. 26, 1925, and Grace Turner asked him why he didn't take him to the county line before he let him go. Jack Woods tried to get Od by radio.

Sam Parks [was] arrested for being drunk at the foxhunters' grounds Sunday afternoon, October 4, 1925.

Sam Parks had a warrant for the arrest of a man by the name of Harrison in Johnson township and he sent word over by some of his neighbors to that effect. Pressed for an explanation Sam said he wanted the fellow to get away as he didn't want to board him until next May term of court. March 3/26.

Elisha Bradley the morning of the [1926 primary], at the postoffice said candidates would wade across deep mud to shake hands but that morning he had to walk to town and buy his own cigar. Man in Hamblen said he would make affidavit that they had voted a man up there who had been dead at least four years. Sam Parks said 50 tombstones were voted already— this was 2 p.m. Rev. Bless at Helmsburg said Wilkerson was the only fit man out for sheriff. . . . Harry Kelp had a sign in his shop window—"Shaves for defeated candidates 25 cents." Regular price is 15 cents. (May 1926)

Monts, the apartment king, wanted to know if Mrs. Sam Parks got her divorce. He was told yes. Then he must know if Sam got his, too. Sam in paying his rent to Montz said he didn't know what to do about paying more rent as he didn't know just where he was in the divorce case, but he guessed another month's assessment wouldn't hurt. Montz 'lowed it wouldn't either. Duard Calvin says Montz made his tenants put in low-powered bulbs and he pulls the switch at 9 p.m. Said his light bill was $2.50 last month and his tenants would have to be keerful. (December 1927)

Sam [as a boy] helped to drive cattle over the mountain all day, cut thru briars for a starry heifer, then back to the road that gave him stone bruises. Received a whole dime for the work. The last four miles walking back home he looked at the money every minute and then put it back in his pocket, holding it tightly. The first money he ever earned. Haven't earned any since, someone said. (February 1929)

80

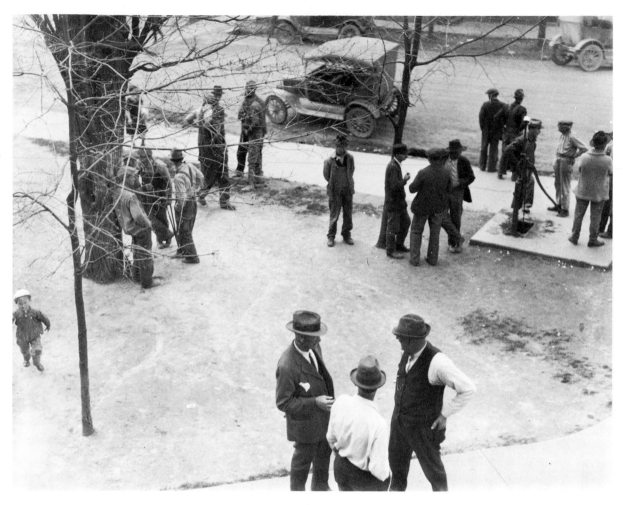

Crowds like this gathered at the courthouse for
every election and trial. This was the view from
an upstairs window on the day of the spring
primaries in 1926.

Oliver Neal brought this rattler to Nashville for
Hohenberger to photograph. July 17, 1929.

Oliver Neal

OLIVER NEAL worked an 80-acre farm on the West Branch of Owl Creek until, at the age of 51, he was hired by Richard Lieber to be Warden of the new state wildlife preserve. He was the first law officer in Brown County not elected and paid by local voters. Ostensibly his job had three aspects: He was expected to supervise the removal of houses, outbuildings, and fences on the property as it was acquired, and to direct the planting of grass and trees. He was to manage the introduction of game birds and deer. And, finally, he was to administer the recently enacted state fish and game laws, which required hunters to buy licenses and observe open and closed seasons for various species.

As it happened, Oliver Neal spent most of his time trying to control moonshining, since the new public lands were a favorite place to hide a still. When not chasing moonshiners he was chasing hunters. The neighboring men were used to hunting for food and didn't like anyone telling them when or where they could hunt and fish.

Neal and his wife, Mary, were second cousins. They grew up around Lanam Ridge and Owl Creek Valley, three miles northwest of Nashville. The Weed Patch Range, site of the wildlife preserve, was three miles southeast of Nashville. If only because he was from another part of the county, and neither kith nor kin to the folks around the state land, he could be conscientious about his work and follow the letter of the law. The Department of Conservation provided his family with a fine house, and he continued in his employment even after the property was declared a state park.

Nov. 4/21. Allie told Mr. Rosebrock that if he saw Oliver Neal the game warden snooping around where he was hunting rabbits to poke out his other eye.

Oliver Neal had been in a shooting scrape, shot going into his face, and Jan. 30/24 while he was standing on the street corner he apologized for not being shaved. A native said if he let them grow they'd keep the shot off.

Went up on Weed Patch with Oliver Neal, Saturday, June 27, 1925. Saw a buzzard on an old tree top. Send in picture of pheasant nest. Johnny Wise says there is a golden eagle's nest in the preserve. 8,000 acres without a school house, church house or graveyard. Water in roadways not bothered. It

Mary Neal feeding young wild turkeys intended to be released in the wildlife preserve, August 1928. This experiment failed but the release of deer succeeded. Deer had been hunted to extinction in Brown County by 1875.

*makes bathing and drinking places for the birds. Bear Wallows up there. Jim
Yoder can give history of the log cabin on Weed Patch.*

*Oliver said when he went to arrest an old man on David's Branch for
hunting on Sunday the fellow said, "Yes, I know it's agin the law, and
besides I used to be a warden under Sweeney, of Columbus." He wanted
Oliver to release him, saying: "Let's forget this and go and have some
watermelon." A little later he caught Jesse Mathis and Louis Selmier, both
hunting on Sunday. Jesse said he was never known to do anything wrong but
what he got caught at it. When he started for Selmier Oliver had to shoot
once to cause a stop. When the two met Oliver asked him why he run, and
Louis said he wasn't running—he just couldn't keep his feet still. Then Louis
wanted to know what Oliver wanted. The first thing the warden asked for
was a chew of tobacco. Then they were both told to come to town, but first
get their dinner. Oliver was at the hardware store to greet them and Jesse
told Oliver that he had been thinking things over and decided he hadn't
been hunting—it was the dog. "But you done the shooting, didn't you?"
inquired Oliver. (October 1925)*

*Had long been wanting a picture of a real still and Oliver Neal told me
he would let me know as soon as he located a specimen. Wednesday
evening, July 21, 1926, he told me had the still for me and we would leave
next morning at 7 to photograph the same. He and his son Fred called at
6:40 and we were on the way a few minutes later. Followed the regular Weed
Patch road to the old building at the crest and then went over past the old
Smith house. Meandered down a very winding road to the right for about a
mile and a half. Nothing but a Ford could have followed the road. Very short
curves and trees right where you didn't want them. We alighted near an old
shed, locked the car and started along a very narrow path. Followed it for a
quarter of a mile and then Oliver darted off the main road. Here he said is
where I discovered the path to the still. My first clue was some spilled water
near the old well, about which something later. The "Y" off the path had a
limb across it which was almost normal, being bent just a trifle and possibly
a few leaves were withered. We sidestepped as best we could down the steep
bank, over logs, having a care for snakes, and when we came to the first
resting place Oliver said, now don't talk and maybe we can catch the hen on
the nest. A little farther and Oliver must have cracked a limb for he
attracted the attention of the operator fixing the fire. He might have seen my
light colored shirt, too, for he started to take to his heels through the narrow
ravine and just then Oliver let go with a round of shot. He said he hit him in*

the back but we didn't know. He was asked to stop but he said he couldn't, and then Fred said give him another and help him. Oliver yelled again to look out for the other fellow or he would run into his arms, but he went on and disappeared in the dense thicket, probably 250 feet from the rim of the hill. Oliver said he was Irwin Mullis and that he had been warned. The still was about five rods over the state reserve line. . . . Water in the barrel was carried from the old well at least a half mile away. The water in the well was almost stagnant and of a dark color—tadpoles were playing in it, and that is the quality of water used to make the liquor, which, I must admit, was quite clear after the distillation. . . . Oliver a natural born detective. The old well possibly a hundred years old. Bear wallow close by. John Reddick wanted a copy [of Hohenberger's photograph] for a novelty. Herschel Mobley wants one, too. Others would like blueprints of the outfit. Officers hunted three hours and then couldn't find the still. Oliver helped them out and when he got right down to the still he put his hand on it and said, "Boys, this is a still." Fred Neal says the operator must have peeled the bark from all the trees in his flight. Dewey Mullis arrested and gave bond July 23/26.

Mullis case: July 30/26. About 35 in court room. Jones helped Rufe Reddick in defense at last minute. Witnesses separated. State didn't get all witnesses in before Squire Calvin decided the state had no case. Began at 10:15 and adjourned in an hour. Crowd remained evidently thinking liquor would be divided up.

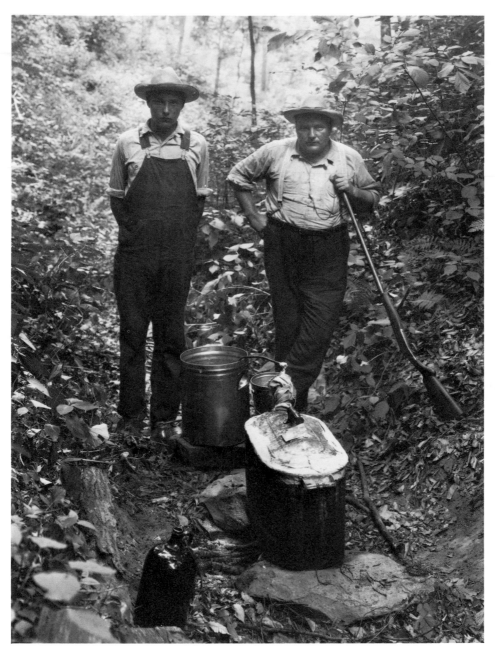

The raid on Dewey Mullis' still, July 22, 1926.
Oliver is shown with his son Fred.

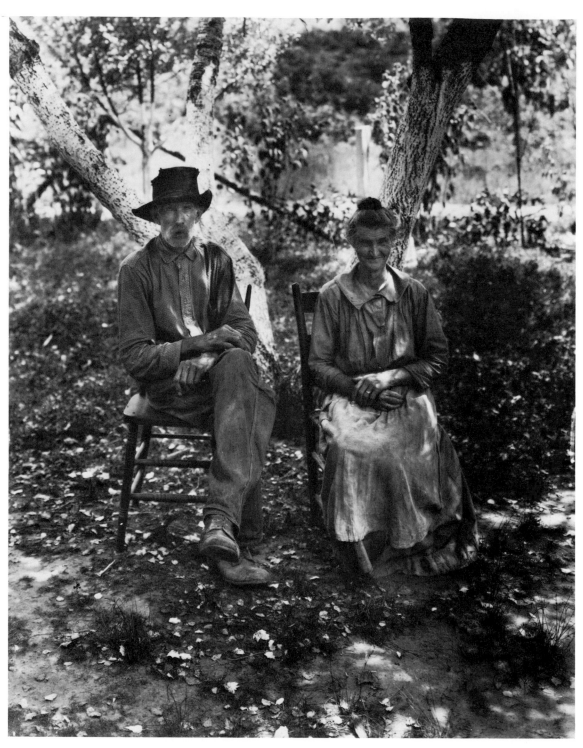

Alexander and Amanda Mullis, August 1, 1922.
Mandy owned 80 of the 120 acres they farmed on
Gravel Creek.

Alex and Mandy Mullis

ALEX AND MANDY MULLIS lived two miles south of Weed Patch Hill, on an upper branch of Gravel Creek. Hohenberger admired Alex for his many skills. He was a careful farmer, and his 120-acre farm was in good shape. He was famous as a breeder of fox hounds. He was a versatile craftsman. But the state claimed the successful along with the unsuccessful, and in April 1925 he was forced to sell his land. There were many Mullis families in Brown County, most of them in Schooner Valley, west of Weed Patch. Alex and Mandy moved to another farm in that neighborhood, which Alex had inherited years before. But in June 1926 that farm was acquired by the state as well, and they were taken in by a cousin, farther down the valley.

In addition to hogs and hounds, the Mullis clan was well known for corn whiskey. The men always professed complete ignorance and innocence, even when caught tending a still. Alex was not caught at all until 1931. Hohenberger's account of the trial makes clear why state or federal officials rarely bothered to bring a case to court in Nashville. It was nearly impossible to persuade a jury to convict a long time resident of making liquor. As one moonshiner said, he could get to nine stills in an hour on horseback. Selling whiskey was one of the few things a man could do to make good money during the 1920s, and it was an accepted part of life in Brown County.

Saw my first rattler in Brown county August 1/22. Killed by Sam Kelly and myself, shortly after we left Alex Mullis's to find an old cabin, to which we were directed by a young Dr. Harrison. . . . The reptile was of beautiful pattern, yellowish-gold predominating, looked like a velvet rug. Had 8 rattles. I brought them home. George Allen determined to bring the body home but was discouraged by Mrs. George Mullis who had been berrying. Carried a large stick. Said she "packed" it for snakes. Stopped at Tom Mullis's also. He lives with old maid sister. Took picture of Alex Mullis and wife, also George Allen and Alex at grindstone.

Shirts the attorney would say "Well, we have sold your land," and the invariable answer would be "Huh, have we!" Some would ask when do we have to get out, others would say they were glad of the deal, some contending, too, that they didn't get enough money for their land. William Taylor's wife said, "We will go over to Nashville and fix up the deeds, etc., I

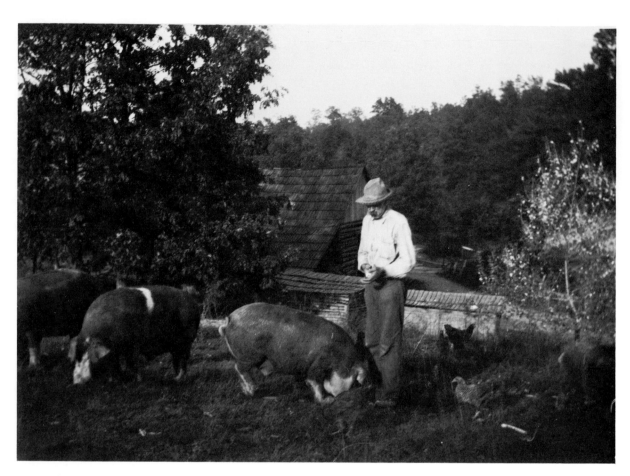

Alex feeding his hogs on his Gravel Creek farm,
about 1920.

have only been there 2 or 3 times." Ehlers said he bet she has never been to the county seat. Or he would say "That woman's never been out of here." The Aynes place will bring $1300.50 and the money is to be divided among 13 children. Hobbs place and old Genolin home in the district. Jim Strahl said he ought to have had more money. If he moves out the rattlesnakes will be on the increase as he claims to have killed lots of them. When Lee Bright would ask for an option they would laugh and say he would never sell their land and they were one dollar ahead. However, when they saw him later they would ask "Sold it yet?" "Think you're gonna sell it?" One man who sold out said it was the only chance he had had and possibly it was the only chance he would have. Joe Roberts was making molasses when the state men drove up. They asked questions about making lasses and then they sprung the surprise. Joe blurred his eyes and grinned. He was one of the easy ones. In making the drives Lee would say drive straight ahead and Ehlers would take exceptions—look at that curve ahead, etc. Alex and George Mullis will probably move to Bloomington. William Taylor may go to Illinois. "Hell, you'll never sell it," was a favorite reply to the option man. Old man Harrison had since posted his place. He was referred to as the two-gun man Simpson. Says he can shoot equally well with both hands. He claims he could fade the state men. He wanted $3,000 for a $560 place. (October 1924)

Alex Mullis wanted a picture of Harrison, who lives east of him. Wanted me to get a particular pose, referring to it as "that form." (October 1924)

Alex Mullis was in town with his son and grandson to see Lee Bright, Oct. 6, 1924. Said he got $2200 for his land. Told about Mr. Harrison, living east of him, not wanting to take $7.50 an acre for his 86 acres. Said when the state men came on the ground he would shoot them down as fast as they showed up, as he was going to get 1,000 men from Kokomo. Alex wanted to know this: "Don't you reckin they'll have all kinds of wild animals in that park? An' won't there be airplane lightin's up there?" Didn't know where he'd move to. Wanted to know if I would be at the fox races at Morgantown next week. Said he had dogs that would pert nigh ride on top of foxes all the time—in the meantime other dogs would be half a mile behind. Is anxious that there be honest judges.

Alex Mullis decided that the price they had fixed on their land was all right. He thought it didn't pay to fiddle with the state. It is thought some of the families will double up, thus handling the "where do we go from here" question. (October 1924)

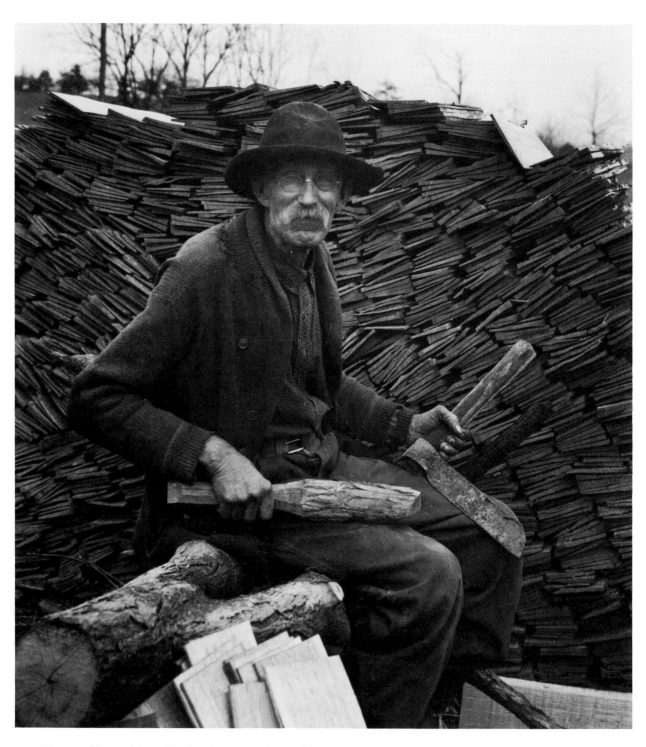

Alex Mullis making shingles for a vacation cabin,
March 11, 1927.

Visited Alex Mullis in the afternoon of March 11/27 with Oliver Neal. He had 2500 clapboards ready for Governor Jackson's cabin. He furnished the lumber and did all the work for $30. These were of black oak. He gave illustration of riving. Says he can make 2,000 a day. They are 26 inches long and from 4 to 6 inches wide. Has been making them for 40 years. Roofs with his shingles all along Gravel and Salt creek. About 16 to a butt. Tree trunks 2½ to 3 feet thru. Trees generally straight way up. No kinky wood will do. These trees were about 100 feet high. He made 10,000 in 4½ days for George Roush.

Alex Mullis at dentist's with daughter. Pull or fill was the question. Alex said to his daughter, "See here, Rettie, w'en they git them thumps nothin'll cure 'em but th' steel." (December 1927)

Trial of Alex Mullis, May 22, 1931. Rained about all day. Room packed to overflowing. Necessary for judge to clear court room to get all available ones for jury clear of the building. Wet day indicated Alex victory. Vene Scrock arrived in time for opening. Held up till he came. Warrant had a flaw— should have said "Sarch" instead of search. Eli's lye used in still. "I've heerd," Sampey David. Saw account in paper. You mean you saw the picture of Alex making clapboards—meaning he couldn't read. When prospective jurors were asked have you had any dealings with Alex there was always a halt before answering—liquor sales. Always a chuckle. German visitor thought court disgraceful. Judge had neither a wig nor cloak, tilted in chair smoking a big cigar. Any relation to defendant? Yep, Aleck's wife cousin to my father-in-law. On jury before? Two-year ago in a stobbin' case. Yep we fox-hunted t'gether. Bought boards for a barn. Anything else? Halted for chuckles. In any other case. Yep, it were a pitchfork stealin' case—feller name Brown. How'd yuh happen t' be in town. Jist happened natcherlly. Civil or criminal case— Yes-sir. One juror would cut long sentences (questions) in two with a yes or no—couldn't remember all of it. How long yuh knowed Alick? 40-year. Are you that old? Ike Shipley—Hard hearin'—nope only one ear. I'm willing to answer any questions. Who did you talk to—dodged it then said if you want to know it was Aleck. Could you act impartially? If I'm choiced, regardless, I'll do the best I kin. I'll be 63 if I live to see the 26th day of August. Spectator on east side of court house was setting on index to law books and a delay was necessary. Wanted everybody outside of court house. Bailiff was lazy (?) and didn't care to travel down street for jury material. When all eligibles left the room the women and young folks gobbled onto the choice

seats. Were driven out in rain. How long have you worked on state road? Oh, off an' on. Where do you live in reference to Alex home? Jist above his barn. Tell direction. Ever see a still out of captivity? When did you arise? 'Tween sunup an' daylight. Where were yuh before that? Musta bin in bed. Crowd chuckled when Sheriff showed familiarity with outfit. Couldn't this have been used for washing—meaning boiler. Never any of that green stuff on our clothes. Dan and boiler—his never had a hole in the lid. One man said he wouldn't let his wife even put holes in doughnuts after this. Alex 75—lived here "all my life." One t'other at th' house read story in paper. Ef I ever seed that biler afore I din't know it. Crowd examined still at front during recess. One juryman got shaved at noon and delayed trial a few minutes. One juryman would not act fair because he respected old age. (Did he mean liquor or human?) Pressed for an answer one witness said, he didn't know the time as his clock stopped. Robinson, prosecutor, said Alex was the sly red fox, clothed in blue (overalls) appearing to be a white lilly. (Patriotic). Alex said after it was all over, "They barked at th' 'ole but th' fox wahren't thaar." Acquitted of possessing a still on second ballot. They had the fox by the tail but he slipped through, Alex said.

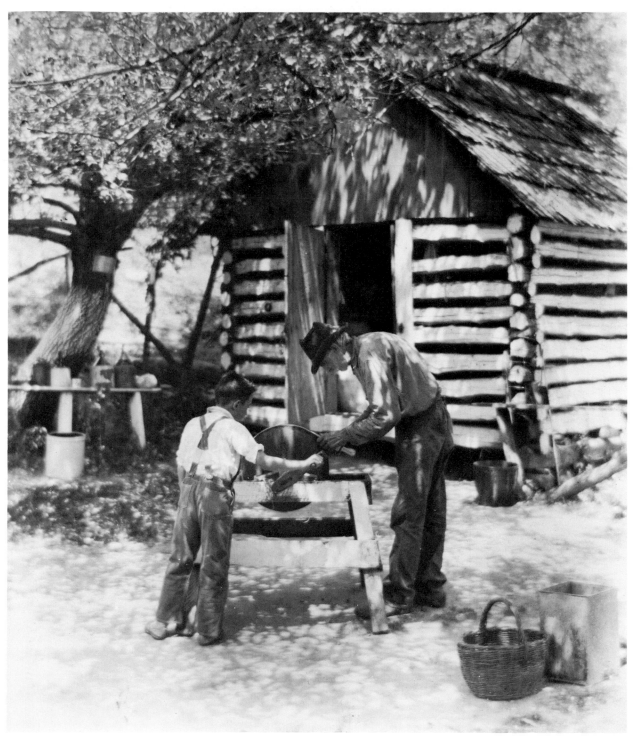

Alex and his grandson George Turner sharpening
an ax, August 1, 1922.

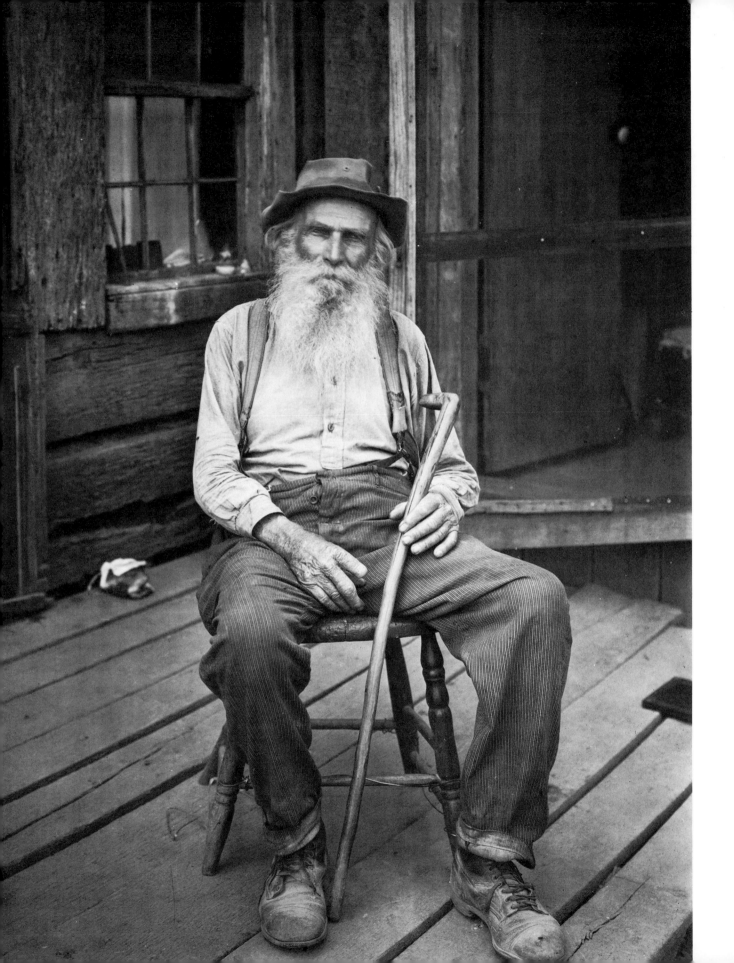

Valentine Penrose

THE ROMANTIC APPEAL of Brown County was largely due to people like Alex Mullis. To an office worker in Indianapolis or Chicago, the idea of a person who could make or grow anything he needed, who was free to follow the rhythms of the seasons, and who could hold primitive beliefs without feeling self-conscious, was powerfully appealing. In contrast to the harsh urban habitat of asphalt, concrete, and iron, these people were believed to live in a natural world of wood, leather, fieldstone, and clay. They were the folk, the last remnants of the pioneers.

Hohenberger recognized character studies of the hill folk as a distinct genre of photograph; this type of subject matter was an innovation of the 1920s. He was one of the first photographers in the United States to make sympathetic, formal portraits of plain country people at home. He tried to keep up with current thinking about these people as a class, sending away for such books as *Our Southern Highlanders,* by Horace Kephart, and *English Folk Songs from the Southern Appalachians,* collected and annotated by Maud Karpeles and Cecil Sharp.

In a sense Hohenberger undertook a field collection of his own. Although he knew some country people well, like Chris Brummett and Alex Mullis, there were many whom he visited only once or twice. In these cases he essentially wished to document what they looked like and where they lived. One such visit was to Valentine Penrose. After a photograph of this 98-year-old patriarch was published in the *Indianapolis Star,* he became an instant celebrity, and tourists would seek out his farm in order to picnic in the yard of the authentic being.

Valentine Penrose was born in Belmont County, Ohio, in 1827. As a young man he worked on steam boats along the Ohio and Mississippi rivers. After the Civil War he brought his family to Brown County, Indiana, following many people (including the parents of Allie Ferguson and Molly Lucas) who had moved from Belmont County to Brown County in search of fresh, cheap land. At the age of 40 he built a new home and settled down to the quiet life of a self-sufficient farmer, probably not suspecting that most of his life still lay ahead. His nine children all remained in Brown County, and Valentine became the apex of a large local clan. In his later years his birthday parties on St. Valentine's Day were large festive gatherings. On his hundredth birthday he served dinner to over 300 friends and neighbors and entertained the crowd by hewing out six railroad ties. He remained energetic to the end, raising 350 pounds of tobacco in the last summer of his life.

97

Valentine Penrose at his home, June 7, 1925.
Hohenberger's 5 × 7 negative holder can be
seen on the porch.

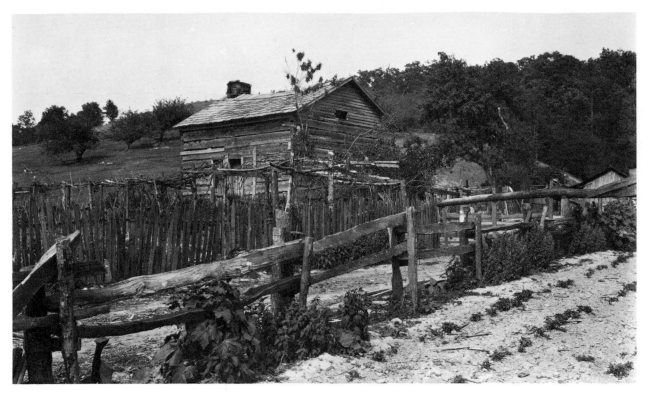

Penrose's house and garden.

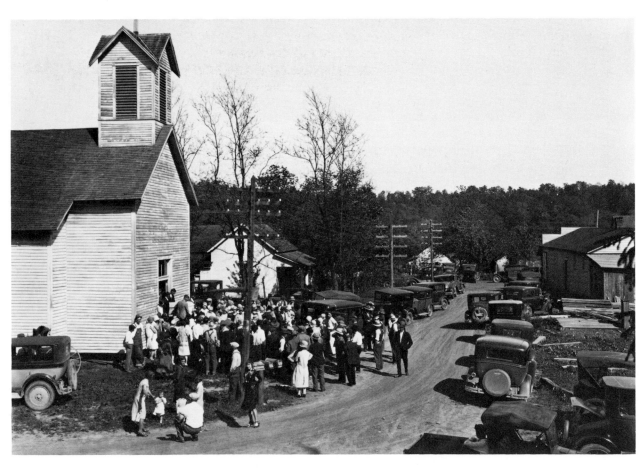

Valentine Penrose lived to be 103; Hohenberger attended his funeral at
New Bellsville on May 12, 1930.

Natives: Old man Penrose near Stone Head, said to be one of the old inhabitants, probably up near 95. (March 1924)

Sunday, June 7, 1925, McMillan and I drove to the home of Valentine Penrose on Valley Branch. Found him at home, living with his son, a Mr. Aynes. Valentine was born on February 14, 1827, in Belmont county, Ohio, and came to his present home in 1865, where he erected a cabin in 1867. Timber for the same close by. In his early days he saw a few deer, wild hogs and turkeys. He did little hunting—had no time for it—was interested in making a clearing. Original and present size of place, 80 acres. His family had 6 boys and 3 girls, 3 boys and one girl still living. Ain't frettin' about when his last day arrives—thinks his time is about out, but he might be here longer than he thinks. With the exception of being a school director, he never held office. Always a Democrat. Not sick a great deal. Five or six years since he handled a gun. Grew corn, wheat, oats and tobacco. Drank very little. No smoking since 30 years back. Before that he always smoked a pipeful after meals. Five years ago he put in a half day hunting rabbits and finally located one which he shot at and missed and the animal sought quarters in a hollow tree. Valentine stopped up the opening and went to the house for help. Aynes finished the trick. Valentine is out around the house every day. Works a little. Dug up a bank with a hoe and planted corn. Belongs to Christian church. Lives on R.R. #4.

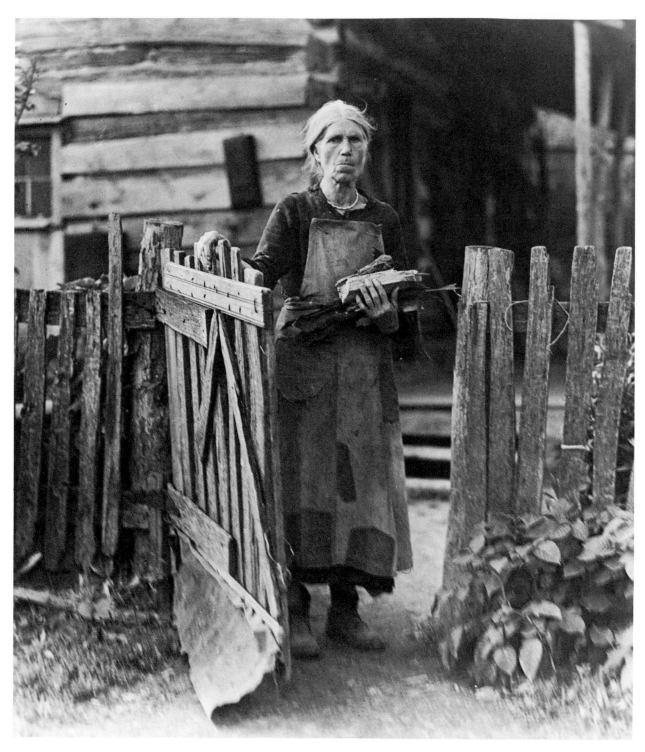

Ellen Petro with kindling at her gate, June 8, 1935.
In the years since Hohenberger's first visit, she
seems to have changed her habit from smoking
tobacco to dipping snuff.

Ellen Petro and Grandma Graham

FRANK HOHENBERGER visited Ellen Petro twice, in July 1924 and eleven years later, in June 1935. The first time he came to the farm on Dry Branch where she lived with her husband, Preston Petro, Hohenberger was looking for her mother, who like Valentine Penrose was going on 100 years of age. The old woman had been married four times; although her legal name was Jane Johnson she was known by her first married name, and most people called her Grandma Graham.

Ellen Petro could read and write better than Preston could, and as was commonly the case it was her role as wife to take care of all deeds, wills, licenses, and certificates required by law. Records in the Brown County Auditor's Office show that she held title to a 78-acre farm, valuated in 1915 at $230. In March 1923 she sold 20 acres to Charles Petro and wife for $125 and 58 acres to William Bargman for $575. One month later she paid $615 for a 40-acre farm on Dry Branch, less than a mile to the west. So, when Hohenberger first photographed her and her house she had been living there little more than a year.

The notes Hohenberger made on the visit of July 1924 are a little hard to understand. When he mentions "Jim Green's mother," "the old lady," "the old woman," "Mrs. Sullivan," or "Jane Johnson," he is referring to Grandma Graham. Otherwise he means Ellen Petro. Ellen considered Grandma Graham to be her mother, although Hohenberger quotes her as saying she was an orphan at the age of seven. He gives her age as 61, although according to county records she was born in 1868, thus being 56 in 1924. Hohenberger reworked this account and published it with photographs in "From Down in the Hills O' Brown County" for April 18, 1925.

As usual, Hohenberger transcribed the interview in such a way as to emphasize for city readers the quaint aspects of speech among the rural people of Brown County, and he posed the two women in settings that highlighted the most provocative aspects of their way of life. In the case of Ellen Petro, he made a special request that she fetch her old-fashioned clay pipe and fill it with home-grown tobacco. She returned to the porch with her pipe but also with a bead necklace, expressing an underlying kinship with the secretaries and suburban housewives who would be appalled or amused by her picture in the *Indianapolis Star*.

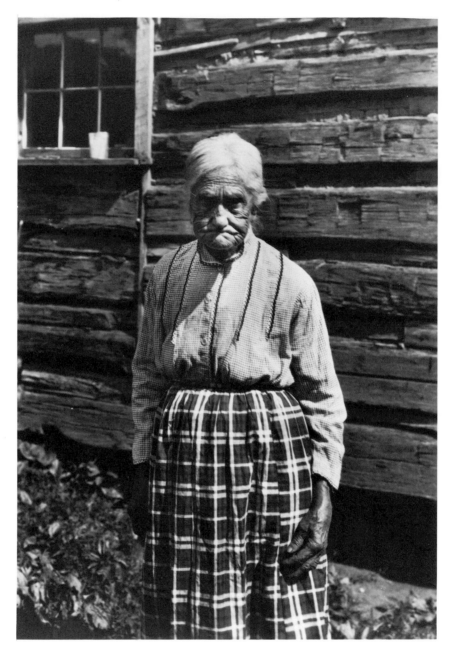

Grandma Graham, taken during Hohenberger's
visit of July 16, 1924.

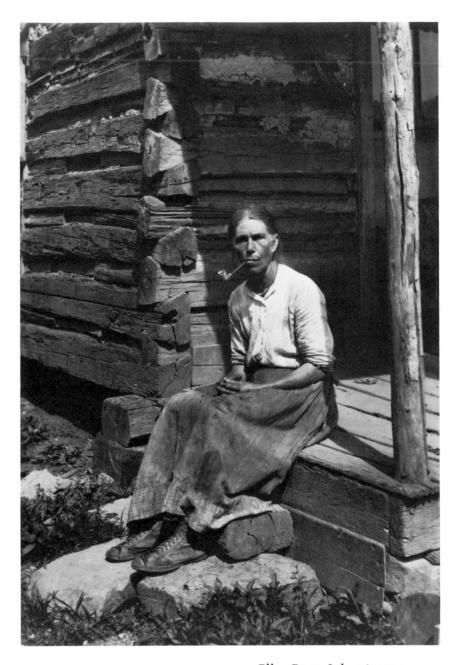

Ellen Petro, July 16, 1924.

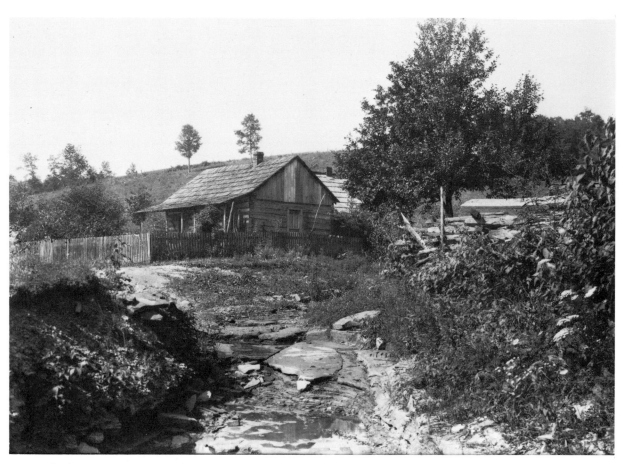
The house on Dry Branch.

July 16/24, left at 8 a.m. with Fred Sinn for the Preston Petro place on Dry Branch. Passed Chas. Breedlove house after crossing the creek near the school house on Lower Schooner. It is the old road on which I at one time made a cornfield picture with Johnny Carpenter. The Petro place is back off the main road and can be seen from the hilly road traveled by the mail carrier. Wanted picture of Jim Green's mother and supposed she would be in bed or perhaps become irritated over having her picture taken. Ellen Petro, wife of Preston, told about Mrs. Bargman a neighbor taking pictures with a small crowdak. Used fillins. Spoke about her being a "newsness"—nuisance. Said also she wasn't any sharper than she ought to be, also was as near nothing as anyone could tell. "Of course we're on speakin' terms." Father of

the old lady was 105, sick only three weeks before he died. Took dropsy.
Folks seldom know what it was to be sick—only had a hurtin' in their
stomach—too much green apples. Parents would give worm medicine and
say it was candy so's the children would eat it. Never saw any sick people, at
least they didn't look any different than other folks. Ellen Petro aged 61. The
old woman was a young old woman when she married—at 19 or 20. Lived
all over Brown county. Her husband was William Graham. Her father born
in Kentucky. Mrs. Sullivan, the name of her second husband, was born in
Walesboro, Bartholomew county. She has remarkably good hearing, a soft
voice, and wonderful eyes of blue. The old lady was in the garden hoeing
when we called. She began smoking after she had two children. Note how
she kept trace of time. She was never educated—can't read nor write. Ellen
can read print, but no writing. Gave up smoking several years ago. Bob
Hatchett was there and said Ellen was afraid to set up her hoe for fear it
would fall over and the handle kill her. Indicating that she was always busy.
Ellen said her father taught her how to drop corn as soon as she could get
over the clods. She was an orphan at 7 and worked out all the time. That
was in the time when there was no law about going to school. Kids were not
so thick then as now and a good worker was in demand. She was a
trustworthy laborer. Did washings and the milking. Most of Mrs. Sullivan's
life spent in Brown county. Lived for a time out of Springfield, Ills. Petro
address R.R. #5. Ellen was smoking pipe with homegrown tobacco.
Explained that blue eyes photograph light—she guessed dirt would take
black. Said she couldn't go clean all the time. Said she had two married and
two unmarried boys. Wasn't wantin' her boys to get married as more's gittin'
married than's doin' good. When she sat on the porch she laughed quite a
bit. Asked her to look different and she said she couldn't. I explained that I
knew I was funny looking, but she said that wasn't it—it was what I said.
Returned home by 10:10 a.m. George White and Jake Breedlove related to
the old woman, whom I learned had been married four times. Her last
husband's name was Johnson. Her given name, Jane.

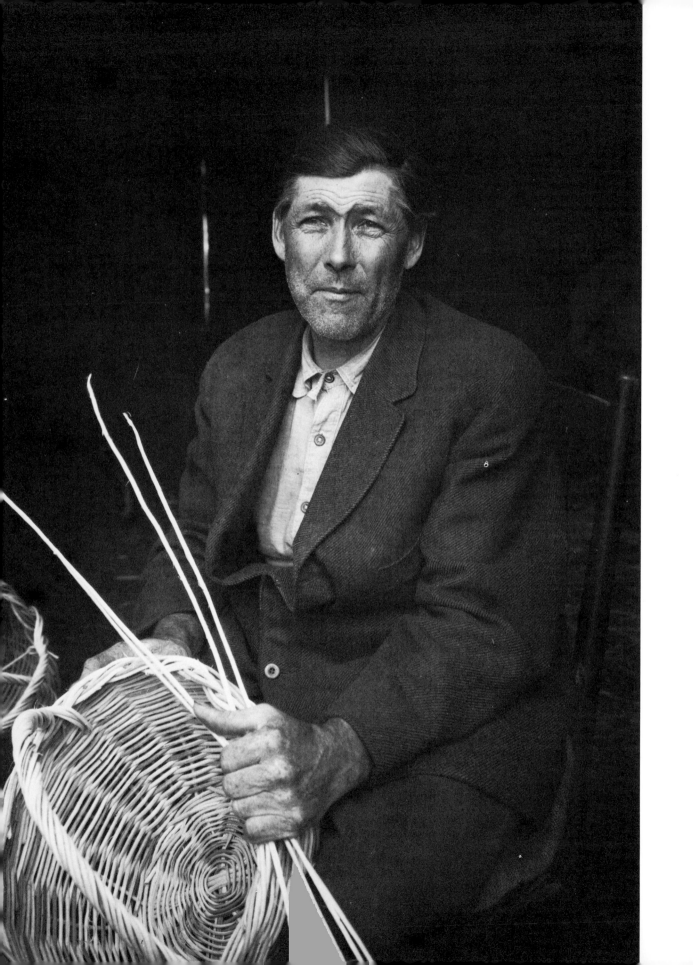

The Bohalls

ONE ASPECT of the popular romance with the past during the 1920s was a new appreciation of pre-industrial handicrafts. Hohenberger was careful to interview and photograph spinners, weavers, quilters, blacksmiths, and woodworkers whenever possible. Some types of craftwork, such as pottery and leatherworking, had become completely obsolete in Brown County. Others, such as spinning and weaving, were remembered or practiced only by the elderly. Quilting remained a vital part of family and community life. Some crafts, such as blacksmithing, were in the process of being abandoned because of the loss of a market. Others, such as basketmaking, were being preserved through the interest of a new clientele.

There was an extended family of basket weavers in Brown County by the name of Bohall. There had been Bohalls in the county for a long time; earlier generations had spelled the name Boughalt. Levi, George, John, Charles, and Joe Bohall had learned to weave white oak baskets from their father, James Bohall. Like most traditional craftsmen, they were farmers who followed their craft as a supplement to the farm routine, trading baskets to their neighbors or selling them to retail merchants in town. But after World War I handmade baskets came to be emblems of simple country life, and therefore there was a great demand for them as keepsakes among the urban middle class. The Bohalls found that they could sell as many baskets to tourists in Nashville as they could bring to town. And they adapted their product, learning to weave delicate flower baskets and fruit baskets in addition to the utilitarian corn baskets, clothes baskets, and market baskets they were used to making. Soon they were sending baskets by the truckload directly to department stores and mail-order firms in Indianapolis.

Hohenberger's visit to Joe Bohall and his family in August 1924 was presented in "From Down in the Hills O' Brown County" on November 1 of that year. Victor Green, a reporter for the *Bloomington Herald*, wrote a feature article about the other Bohall brothers, who lived nearer to Monroe County. This article, printed May 14, 1927, said that "the secret of weaving white oak baskets has been in the Bohall family for generations and probably will be for generations to come. It is a family institution and the Bohalls are proud of their 'profession.'" The Bohalls did excellent work and deserved to be proud of their baskets. But as it happened, the next generation of Bohalls did not learn the family secrets of basket making; without exception, the children and grandchildren moved to larger towns in the region in search of factory jobs.

Hohenberger did this character study of John Bohall during his visit of November 4, 1927.

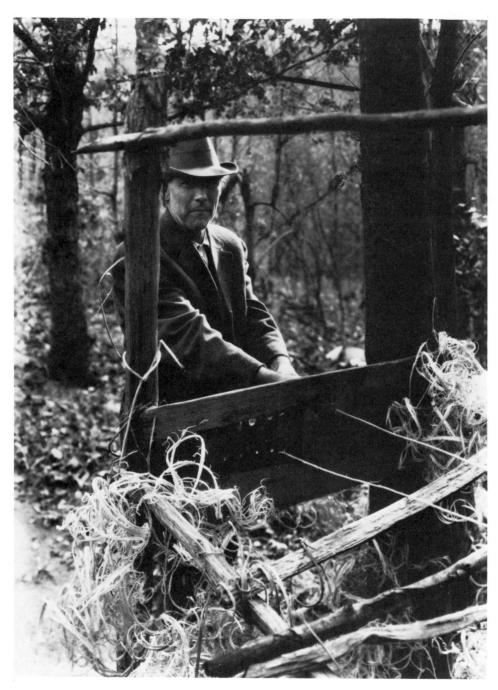

All the Bohall brothers used the same method for
sizing their splints, or reeds: dies cut in the blade
of a cross cut saw.

Nov. 22/19 while I was cleaning sidewalk at Turner's, Mrs. Shulz came along and we got to talking about the basket she had on her arm. It proved to be one made by Mrs. Bohall—Dude Mobley's mother-in-law. As a rule women are not permitted to learn the art of basket-weaving in Brown county, but illness in the family was the direct cause of the transfering of the secret by Mr. Bohall. Mrs. Mobley said they cost so much because you tear so many clothes in making them. Emphasis on the secret—soft and low. The half bushel size which Mr. S. had sold at 80 cents.

August 21, 1924, Bowen Sims and I left here at 9:15 to have an interview with Joe Bohall and family off of the Story-Elkinsville road. Arrived there at 10:20. The road after we left James Wilkerson's was merely a path through the weeds. Tall grass in the center. Numerous creek fords, very topsy-turvy at places. Only one road to follow and you couldn't get lost and no need of worrying about having to turn out for another car. Drove right up to the big gate. At first one boy's head appeared, then we found Joe on the porch, and his wife came out to see who might be there. Finally Bill, the basket weaving assistant arrived and the crowd was all represented. Went to the old dingy-looking stable where the workrooms were. At the left were several horses munching the hay and on the right was a cow looking rather inquisitive. Joe posed with baskets and then Bill pulled some splints through the holes out in an old crosscut saw blade. 5 sizes of holes. White oak is used exclusively. Splints 6 feet long for small baskets and 7½ feet long for bushel size. . . . Joe has been making baskets since he was a kid. Is now 53 years old. Probably learned the art from his father, James, who lived on the Muscatatuck in Jackson county a long time. Joe born in Brown county. He said William Lewis, of Walnut street, Indianapolis, was here at his house last Sunday to get some of the splints to experiment in furniture making. Joe has lived in this house for fifteen years. He never has any family fights but his wife said once in a while they do some loud talking. Joe was afraid we were making pictures to have others make fun of. Grover David said he at one time had 450 baskets in his loft and sold them the following tourist season. Joe brings in about 100 a month. The boy makes two small sizes and get the splints ready in a day. The father makes his splints and two bushel baskets in a day. The timber is carried on the shoulders of the family from the hillsides. No superstition about having the women folks learn the art. It was decreed by the fathers that they would learn the sons only as they were afraid others would get next to the art and competition would mean drop in prices. Joe gets 60 cents for the small size. Jim Frost, Berg's father, west of town, also weaved splint baskets.

Joe Bohall and son Billie called on me the morning of August 29, 1924. He said about learning the trade that he wouldn't take no showin'. Said knowed for knew. Made baskets with two strips to start with. Henry Hovis an old weaver still alive—works somewhere between Houston and Freetown. 20 and 24 strips used in starting. Levi Bohall taught John Turpin on David's branch. In making the splints an ax, then a knife and finally a frow is used. When a boy Joe made a basket and got a pair of boots with the money. It was made of hickory and he says it was a "shiner." Platting is hard on fingers. His wife used to plat. Anna Shipley was a basket weaver. Only one out of 600 who don't get their fingers hurt. When the splints or finished basket become dry and slick they are sprinkled in order to facilitate the weaving. Joe and his stomach trouble. Lou Hovis was also a weaver—now dead. Splinters in fingers. Can pull 100 splints in an hour. Mrs. Bohall used to do that part of the work. He said he would have asked us to stay for dinner the day Bowen Sims and I were there but he didn't know it was so late. "Wanted his pickter tuck." Charley Winkler of near Maumee, see Dan Miller who comes here, can tell about a woman doing carpet weaving over there. "Old and broke down," a favorite expression. When Joe wants a change he makes ties—make money faster. Hard on the horses, though. Joe has one daughter married, at Bloomington.

Bohall the basket man could see afar but not the other way with new glasses. Said dust got in his eyes. Wife said he could neither read nor write. Made him mad. Bohall thought if he had glasses he could read like other folks. Had a child mind. Williams tells about his child thinking that there was something in the pencil that made you able to draw. . . . Woodpeckers working on Williams porch in February. He told it to Bohall, who always would say peckerwoods. (September 1927)

J. P. Bessire, Edward K. Williams and myself went to John Bohall's November 4, after dinner. Bohall is a basket maker. Is 50 years old, and has made baskets for 35 years. Crossing a branch that empties into Stevens creek one sees some fine beeches and big rocks. (November 1927)

With E. K. Williams, to John Bohall's, Monroe county, July 30, 1929. Left here at 1 p.m., over the #46 detour by way of Jim McGee's and Pine Bluff. It is about 20 miles to his home. His wife and daughter Myrtle and the baby at home, John cutting hay in field over the hill. Came home shortly afterward.

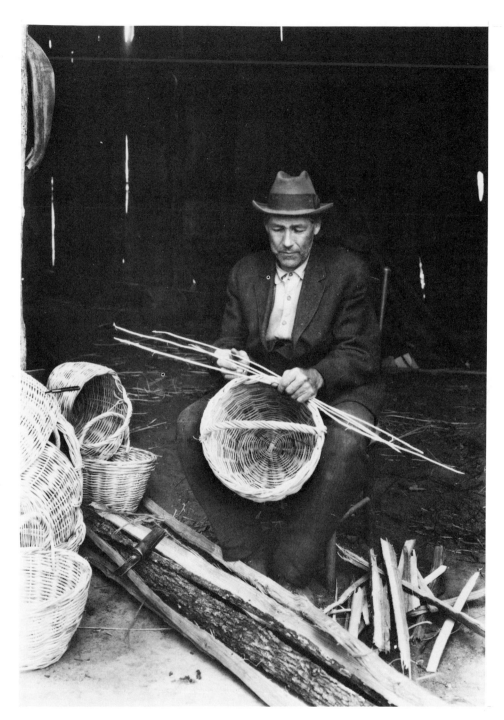

John Bohall in his "factory."

In the meantime his wife cut loose and told everything. An old bachelor of 50 lives near by and one day her mother and daughter cut through the field and came upon him. The old man was very shy of women and avoided the group. Myrtle in explaining the scene said, "He never runned frum may." Later the fellow wanted Mrs. Bohall to do his washing but he never showed up. When John's wife was sick he tried to do the washing for the family. He inquired how much soap, etc. Myrtle kept running to the bed to tell her mother how her father was doing and if he had knowed it, according to Myrtle, he would have skinned her. John is a basket weaver and in order to make ends meet tried to teach his wife the trick, but he couldn't succeed so he told her, "It's uv no ust—I kaint larn yuh." Mrs. Bohall has a large goiter and when she pressed her neck she said, "I've got a garter an' I've putt idyin' on it an' it hurts." A bird's nest in the big oak in the back yard was filled with young and in describing the family John said, "The hen bird's right yaller." Myrtle added, "The rooster and hen sits t'gether over thar." Mrs. Bohall said, "Don't that bird holler sweet?" A wren kept taking tacks out of a can in a shed and scattered them over the yard. Mrs. Bohall had to pick them up to keep the baby from stepping on them. The wren wanted the can for a nest. Mrs. Bohall said her man wanted to go to the ball game and the family went along. "I'd ruther stay at hum an' take keer uv a baby than t' keep hit *still over thar." Mrs. Bohall a repeater in conversation. She did 98% of all the talking. I made notes and Williams smiled. Telling of a neighbor she said, "He's dead—he died." "One foot in the grave an' t'other out uv it." "I liked his wife afore she died. She's dead now." Her mother married an old man who had paralysis shortly after they tied up. "Mom killed herself plum up. She won't marry agin, I spec, I said. Mom had t' pack him about." The ole man in th' holler won't hardly* luck *at a woman. Telling of Bessire she said, "He ain't uv our kind uv people." John called the cardinal the old-fashioned redbird. When asked why they didn't pick the blackberries along the path to the house Mrs. Bohall said, "We like 'em but them chiggers be awful. An' it don't do no good t' scratch th' itchin' 'cause they've got laigs on both sides uv 'em." She called them blackburries. Arrived home at 4:30. Williams expects to paint a picture of Bohall later on.*

Myrtle Bohall, in the road near the family farm on
Allen Ridge in Monroe County.

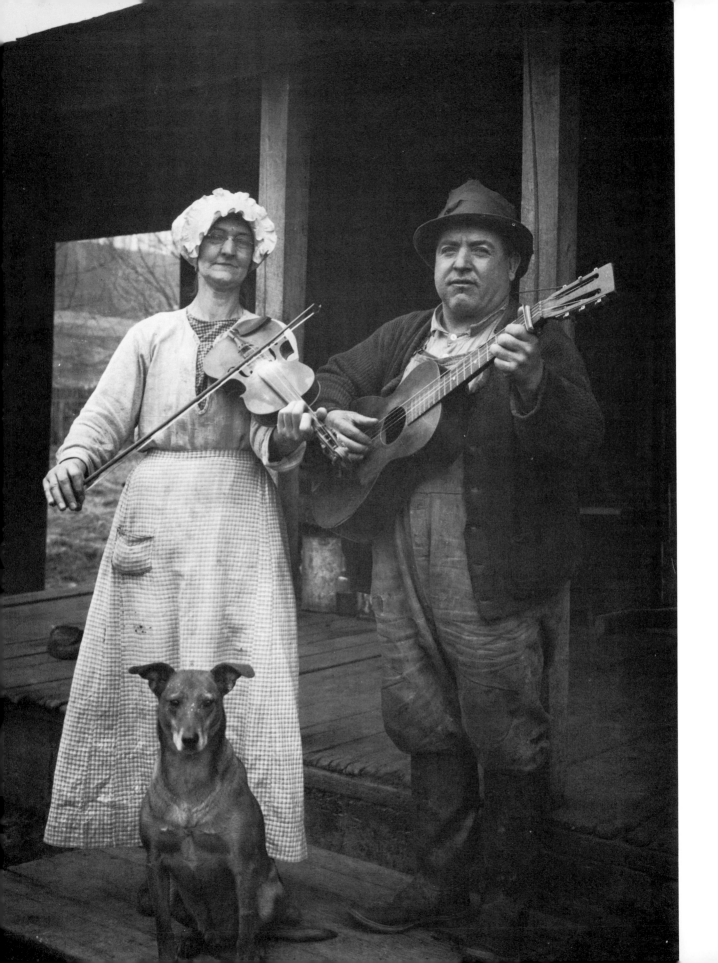

Doc and Diner Beisel

NOT ONLY TRADITIONAL crafts and architecture but also traditional music enjoyed a vogue during the 1920s. The upper classes were charmed by printed collections of archaic ballads and folk songs. To the working classes nothing represented the old times better than an old-time fiddler, and rural string bands were very popular in the new recording and radio broadcasting media. Henry Ford undertook a nationwide effort to sponsor fiddlers' conventions and to reintroduce Anglo-American country dancing, as an antidote to the feared immorality of Afro-American jazz.

Square dances had been an important part of social life in Brown County. The tunes were evolved retentions of forms developed in the eighteenth and nineteenth centuries: jigs, reels, hornpipes, waltzes. The figures were derived from set dances of the early nineteenth century, specifically cotillions and quadrilles. Allie Ferguson and Mollie Lucas liked to reminisce about weekly dances held in Nashville when they were young. These dances were discontinued around the turn of the century, but similar gatherings continued in the rural townships for another generation or two.

Surely one of the most bizarre episodes in the cultural exploitation of Brown County involved Mary and Vincent Beisel, two musicians who lived in Hamblen Township. Their neighborhood was easily reached from Indianapolis and attracted several weekend commuters. These city people wanted to attend the native dances. When they learned that the dances were no longer held regularly, they revived them, inviting people from far and near to come for old-fashioned hoedowns. Hohenberger was the guest of a Mr. and Mrs. Heckman for one of these events in September 1924.

One of the gentleman farmers in the township, John George, was acquainted with Herbert Jennings, manager of the Palace Theater in downtown Indianapolis. George took a contingent of musicians and dancers, headed up by the Beisels, to Indianapolis to audition for Jennings, who booked the group as a novelty act. Their show, billed as "Brown County Fiddlers," recreated a backwoods barn dance. This act was so popular in Indianapolis that Jennings booked the Beisels on a tour of the midwestern vaudeville circuit. In the new act, called "Brown County vs. Broadway," the Beisels played against a four-piece Dixieland jazz band. The crowd was then asked to answer by their applause this question: "Is jazz losing its popularity and is not the music of days gone by again gaining favor?" It seems that most audiences were undecided. The people of Brown County, as usual, were uncertain whether to be honored or embarrassed by the attention given their own kind.

Mary and Vincent Beisel, known to their friends as Diner and Doc. At home, February 5, 1926.

The Beisels' house in Hamblen Township, June 12, 1927.

Hohenberger attended one of the first shows at the Palace Theater and reported on the whole affair in his weekly column for May 15, 1926. The following winter he visited the Beisels at home and photographed them on their porch, their career in vaudeville behind them. More than a year later, on an overcast summer day, he returned to photograph the house itself.

Dances were held in the old carding mill now used by Grover David as part of garage. When one who had been away for long time returned to the village it was customary to pay them the compliment of a dance and affairs

116

were arranged on short notice. Generally two fiddles was all the music necessary and they supplied enough music for five or six dances. . . . Very seldom a dance broken up by a drunken sprawl. One time a man got on the floor and they pushed him into a woodhouse and locked him up until festivities were over. Whiskey and cigar drummers coming to the Mason and Mannvile taverns were introduced to the dancers and were made to feel at home very quickly. Molly said there wasn't any of them high kickin' women in them days. Three and four dances a week. Quiltin and comfort tackin's, spellin' bees, prayer meetin's etc. Never run over midnight. Next morning had to roll out early for work. There wuzn't any of that whistlin' fer partners, said Allie. (October 1923)

Sunday, September 6, 1924, Doc Winter and I went to the Harry W. Heckman cabin a few miles south of Nineveh. It is a one-story affair, very long. Screened in. Built from logs off the place—oak and silvery poplar. Sassafrass porch. Mrs. Heckman superintended the building, also drew the plans. 5 rooms. Native carpenters from Nineveh. Big fireplace. Visit there most of year. Mr. Heckman 42 years old, has meat market for retailing at Indianapolis city market. Set out about 1800 peach and apple trees. Studied horticulture. Had blowout and 150 were there. A lot of natives—one family of 33 children and grandchildren. Mrs. Anderson, a native fiddler, with one wooden leg, also other relatives, furnished the music, she keeping time with the peg. Also had "gittar" and a brother helped with a fiddle. Began to arrive at 7:30. Natives thought Heckmans were bootleggers as they had a basement and always came down from the city in the evening. They danced the kind of dances the natives could pull off—square ones, mostly. Guests came from surrounding cities, too. Generally accommodated 4 sets in dancing.

Old-time fiddlers: Joe Swift and John Wagner, Vincent Beisel and wife, Hamblen township. John Campbell at Dolan on state highway. Wes Campbell at Mt. Liberty. Elvin Hampton, Kelly hill. Jake Henderson and Mose Garret at Hamblen School. Bill Crouch, Sam McLary and Jim Kennedy of Nashville. John Henry Condon, 1 mile east of Goshen church Emmet Hamblen ½ mile east of Condon's. Newton Reeves on Gravel creek. Marion Stogsdill at Elkinsville. Wesley Chandler near Vernon Deckard's. Old postoffice of Ghent used to be near there. El Moore at Bellsville. (January 1926)

Ruth Bond didn't like the idea of Bisels being chosen to represent the county—they had better musicians in Helmsburg, in fact the music teacher

117

that came from the city every week was a heap better. Oddy Green says he isn't from Brown county—just over the line, but he ain't so far he can't smell Brown county. What does he mean? (April 1926)

Doc Beisel and wife entered restaurant on their tour in vaudeville circuit and when the waiter had brought their order Doc wanted to know how much it was—$2 the waiter said. Doc told him later, if my manager inquires for me tell him I've gone out to get something to eat. (December 1927)

A makeshift dam near Doc's water-powered saw mill.

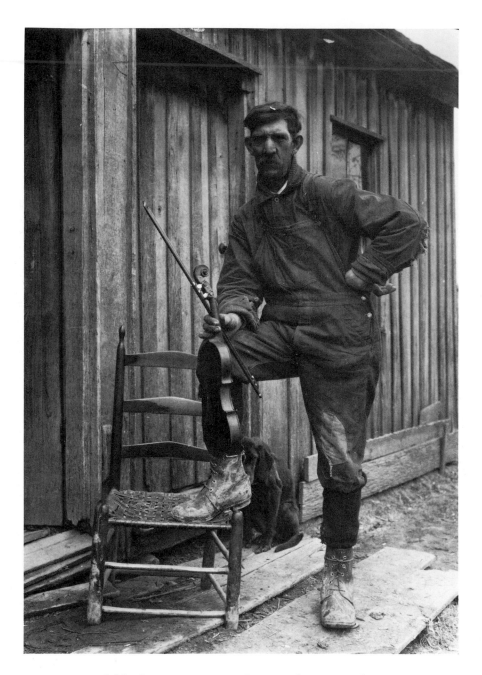

Oddy Green accompanied Doc and Diner on their tour of vaudeville theaters. He was well known for his ability to play "Pop Goes the Weasel" while holding the fiddle behind his back.

Ed Voland

ED VOLAND grew up along Greasy Creek just north of Nashville. When he was sixteen he started an orchard on the highway to Indianapolis, but a few years later sold the place to Dale Bessire, a young artist from Indianapolis. Voland soon learned to be patient and tactful in dealing with the newcomers, for he realized that he had to explain to Bessire in great detail how to operate the orchard while being careful not to imply that Bessire didn't already know all about it.

In 1910, when Richard Lieber began to build a vacation house in Jackson Branch Holler, he asked Bessire to recommend a handyman. Bessire suggested Voland, who at the age of 21 became Lieber's caretaker. Lieber's diaries for the period are in the Lilly Library at Indiana University, and glued to the page for October 30, 1911, is this item from an Indianapolis newspaper:

"He found the Potatoes"

Do sweet potatoes grow on vines, on top of the ground, or do they grow, like other "spuds" in the ground?

If you do not know, ask Richard Lieber, for he has gained intimate knowledge of the question from experience. Mr. Lieber has a farm and bungalow in Whipperwill Hollow, Brown County. He spent two weeks there recently, and on returning to Indianapolis told a joke on himself, and incidently revealed the fact that though he may be a good business man he is not a practical farmer. Mr. Lieber last spring planted a row of sweet potato plants, and the vines grew amazingly in the rich soil of the hollow. The ground was covered with thrifty looking creepers, and Mr. Lieber had the right to believe he would have a good crop of "sweets." When he was at his farm last week he took a hoe and cut off all the vines, but failed to find even one potato.

"Guess they ran to vines instead of tubers," said the amateur farmer.

Mr. Lieber next day told his hired man that he could find no potatoes on the vine, though he had carefully gone over the patch.

The hired man smiled, took a hoe, stuck it into the loose soil of the row, and began rolling out the sweetest kind of sweet potatoes. Mr. Lieber asked his daughter to bring a basket, but it was soon filled. Then Mrs. Lieber brought a clothes basket, and it, too, was filled to overflowing, with the hired man continuing to haul out potatoes by the score. Finally Mr. Lieber ran and brought a tub, and the crop was harvested.

This incident, and others like it, did not humble Mr. Lieber in relating to his hired man. His personal papers and letters, kept in the Manuscripts Division

121

Ed Voland sharpening his saw in front of a display
of Dale Bessire's apples.
Main Street, Nashville, November 14, 1927.

of the Indiana State Library in Indianapolis, include several imperious notes written to Voland during the early 1920s. During these years, Lieber was paying Voland two dollars a week to look after the place. At the same time Voland was farming 67 acres on Greasy Creek and working in Nashville as a carpenter.

In 1927 Voland participated in a subtle but significant change. He was part of a crew hired to build a new, three-story hotel at the downtown intersection. The Nashville House was the first building in Brown County built according to printed diagrams and written specifications. All the men in the crew, who were used to doing calculations in their heads according to well-known customary designs, had a difficult time reading the plans. Their colorful folk methods had finally been accosted by a piece of paper. The out-of-plumb appearance of the finished hotel was a joke for many miles around. The laughter was forgotten after the Nashville House burned in 1943.

Ed Voland tells about a Greiner who had killed his dog 2 years ago. Both men were at a Holy Rollers meeting April 3/21 on Greasy creek. G. got lots of religion and walked down the aisle to the rear of the church where Voland was seated and cried out: "Here's a man whose hand I want to shake." He even kissed Voland.

Ed Voland was hunting foxes on the ridge across from his Greasy creek home and finally shot an animal who was able to run quite a ways and he followed a man whom he thought picked it up, to the Wash Barnes cabin. When he got in the house Fred was putting on his shoes as though he had just got up. Some deceit, they say. (February 1924)

Carpenters working on the new Nashville Hotel got balled up the line of windows from top to bottom and got three of them way out of plumb. They were kidded a great deal. Finally Ed Voland, working on the gingerbread decorations was balled out until he got mad and quit on that line of work. Clayton George, the contractor for the moving, said Ed got the "cornishes" bad. (June 1927)

John Voland offered a reward to anyone who would take Dale Bessire out on a fishing trip and let the work at the new hotel go on without him. (August 1927)

Hotel architects had three sets of blue prints. They worked on one set in the morning, another after dinner and late in the day took up the third.

122

Much confusion. Dale Bessire said he was going to paper the lobby with the blueprints, a fine pattern, and guests could lie on their back and study the progress of the work. Griffith said blue prints were as easily understood by the native workman as a mosaic floor. . . . Clark Campbell said the blueprints were all wrong and he went according to his own ideas. He quit rather than tear down ½ of the work. Later saw him chasing the scoop in leveling the grounds. (August 1927)

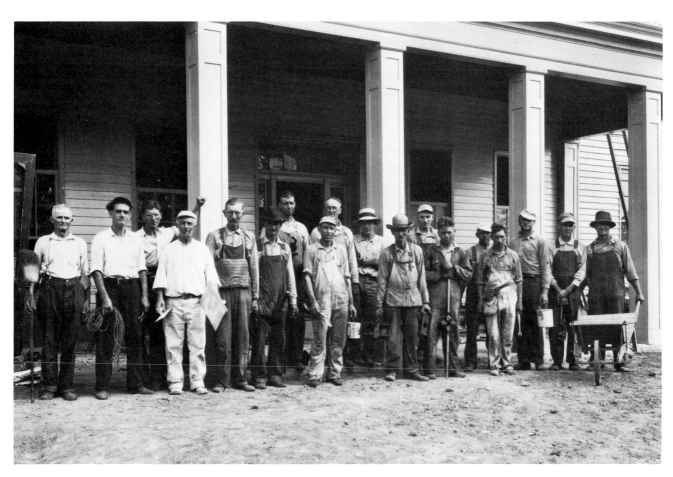

Workmen at the Nashville House, September 6, 1927. Several different kinds of tradesmen may be identified by their distinctive tools and workclothes: electrician, plasterer, carpenter, painter, glazier, pipe fitter, plumber, mason. Ed Voland is fifth from left. His brother John is first on the left.

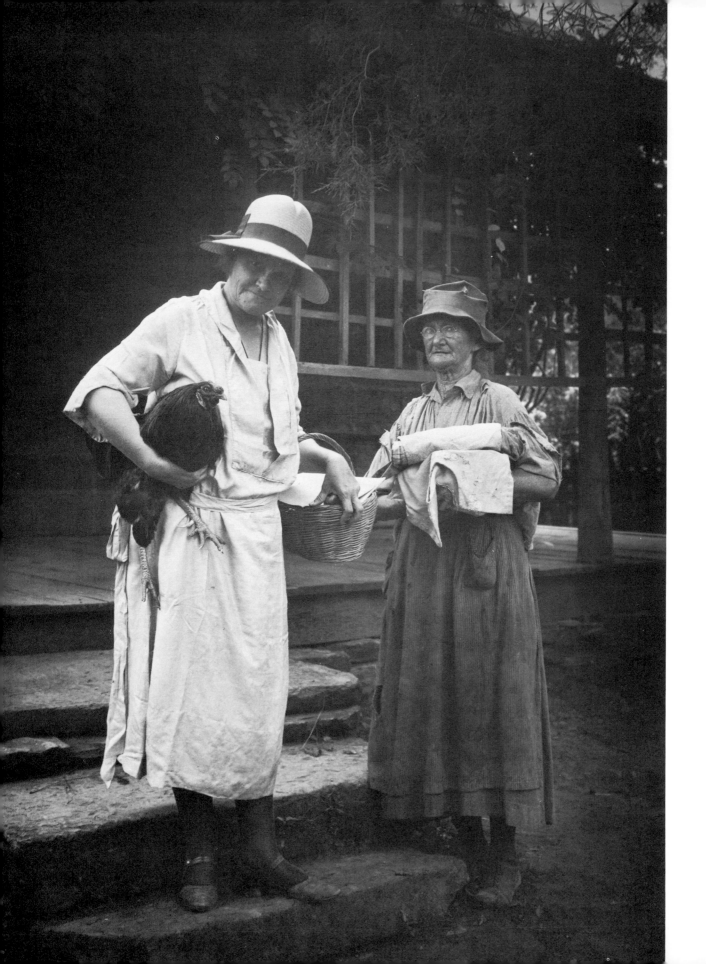

Grandma Barnes and Wash Barnes

IN THE EARLY PHASE of the art colony the arriving artists preferred to walk from the railroad station at Helmsburg to the hotels in Nashville. As the road neared Nashville, from Low Gap to Watton Hill it followed Owl Creek Valley. There were three side roads called Owl Creek Road—one up the east branch of Owl Creek, one up the west branch, and one down the main branch to Salt Creek. These side roads were the first ones in Brown County explored by the artists in their quest for rustic charm, and the vicinity became a familiar sketching ground. Hohenberger included this statement by Carl Graf in his newspaper column for November 27, 1926:

> "Have you ever been up the Owl Creek Road?"
> That is a question I have heard so often, and oh, what it means to have answered "yes." Scattered along the road are cabin homes and barns marking places where pioneers have lived and toiled, and we may still call them pioneers, for the progress that has destroyed many places of natural beauty has not reached into this valley to take away the charm that nature gave it in the beginning.
> Oh, how delightful to an artist!

Over the years, of all the cabin homes in Brown County, the Barnes place on the east branch of Owl Creek was painted by more artists than any other. And of all the living pioneers, Washington and Mary Barnes were their favorite portrait subjects. Grandma Barnes was known for being talented in her flower garden, kind to animals, peevish with artists, and mean to her husband. Wash, it was agreed, was lazy and sometimes carried his storytelling too far. But most people liked him and enjoyed spending time with him when he came to town to sell his brooms on the street. The man and wife did not speak to each other during the last several years of their marriage, and Wash was forbidden to enter Mary's half of the house. You cannot ask about the family in Nashville today without hearing the story that in 1929, when Wash died in bed in his separate room, Grandma Barnes would not allow his body to be carried out through the front parlor. The Coroner and Sheriff had to remove the bedroom window and hoist him out the opening.

In 1929 the artists proposed an annual community festival. In contrast to the Old Settlers' Reunion and Bean Dinner Day, the new festival was to be publicized widely to encourage more tourists to come to Nashville in the spring.

Grandma Barnes with the artist Ada Shulz, August 9, 1926. Grandma Barnes posed for her regularly, kept her supplied with eggs and butter, and did her mending and washing.

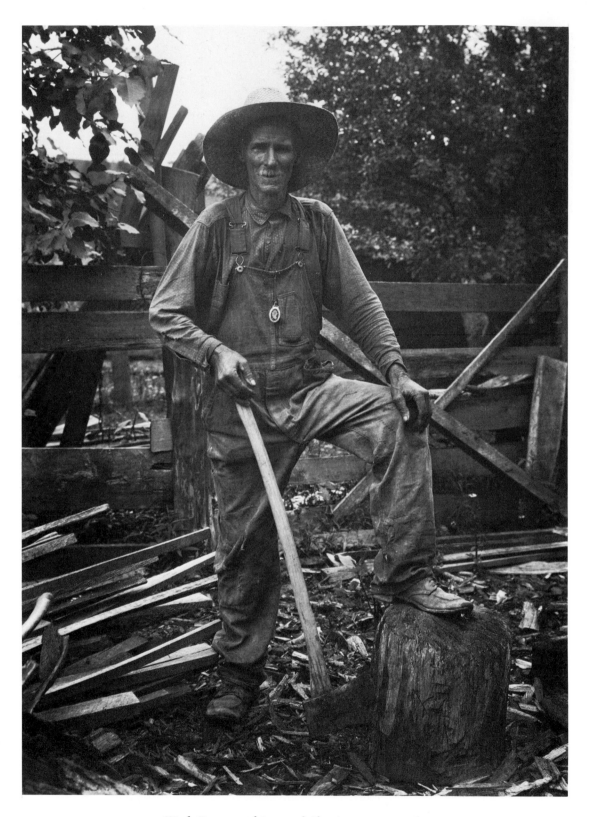

Wash Barnes at his woodpile, August 9, 1926.

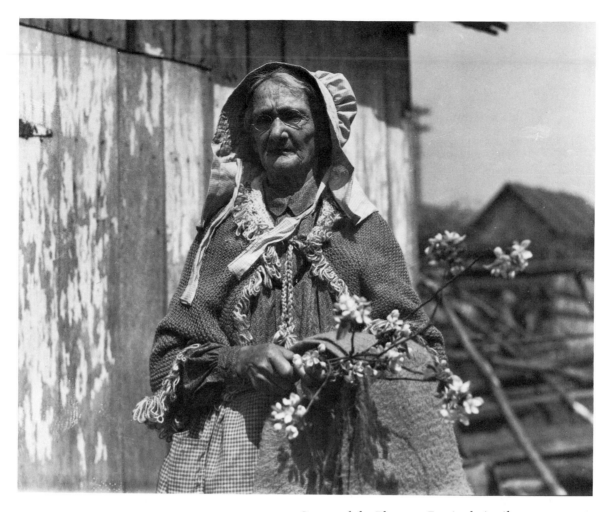

Queen of the Blossom Festival, April 13, 1929.

To the astonishment and anger of the local committee, Dale Bessire insisted that Grandma Barnes be chosen queen of the first Brown County Blossom Festival, instead of the customary teen-age beauty. The artists felt that the old woman represented the best of what the county had to offer, and because of their attention her farmstead became a landmark for tourists. Eventually the county officials agreed. When she died in 1940 at the age of 87, the road to her "lost cabin" was renamed Grandma Barnes Road. She and Wash sleep side by side in Lanam Ridge Cemetery.

Mrs. Barnes began jumping on me as soon as I hit the doorstep. Took the ladies in the party for a stroll through her old-fashioned garden. Gave them seeds before departing. Posed for chick-feeding picture. (June 1918)

Beryl, Georgia and I went over to see the Barnes flower garden June 30/ 19, leaving here at 3 p.m. Lots of flowers there but no chance for a simple composition. Finally secured a nice negative of Georgia in the garden— posing against an apple tree. Tobacco was planted all around. Used film, f.8, 3t filter. Two seconds about 4:45 p.m. A fine clear day. Very hot. On the way back turned up to the Cook home and wished to see the wheat field at McLary's. Vawter was near the old Cook home painting. Arrived at house 6:05 p.m.

Trip to Barnes cabin Aug. 16/22 10 a.m. with Sam Kelly and Kathryn. Fred and Wash were putting down a new floor in old kitchen. Roof wasn't worth anything. They preferred to leave it up so they could work in shade. Mrs. Barnes gave the Mrs. a cactus and bunch of phlox. Also some grapes— different varieties. Allen Turner tells about leaky roofs thusly. Man by the name of Sciscoe would wet some bed clothing before retiring in a good house as he would be unable to sleep if he didn't have a lot of airholes around the roof.

Jake Joy sent me this message. He had been calling on the Barnes family and always found the old man and son Fred in bed. The last time he went up he said he wouldn't go any more. It was noon and Fred and Wash were still in bed. Said he was afraid he would get the sleeping sickness. (January 1924)

Carl Graf and Miss Goth called at the old Barnes cabin on West Owl creek and wanted to paint the place but they were halted by a female voice who gave them to understand that they paid good money for the spot and if Graf wanted to paint it they would want money for it. They knew that artists got money for their canvases. The artists decided to pull their car up to the lane near a gate and paint therefrom and when the trio in the potato patch saw they were outdone they all went to the porch and sat down. Jim Yoder said he wasn't going to allow any artists on his place either as he said he had a valuable cow to die and when it was dissected by a veterinarian he claimed it was poisoned by paint. (August 1924)

128

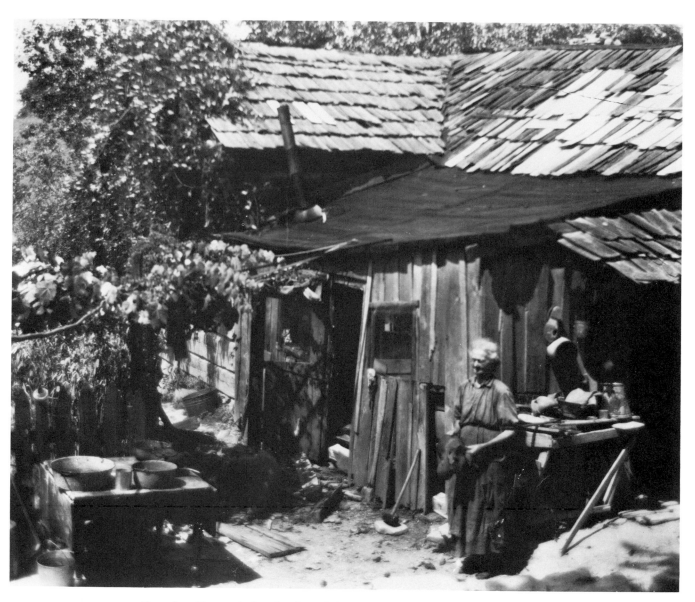

Grandma Barnes in her backyard the day Wash and their son Fred were laying a new kitchen floor, August 16, 1922. At the end of this visit Grandma Barnes gave Hohenberger's wife a cactus.

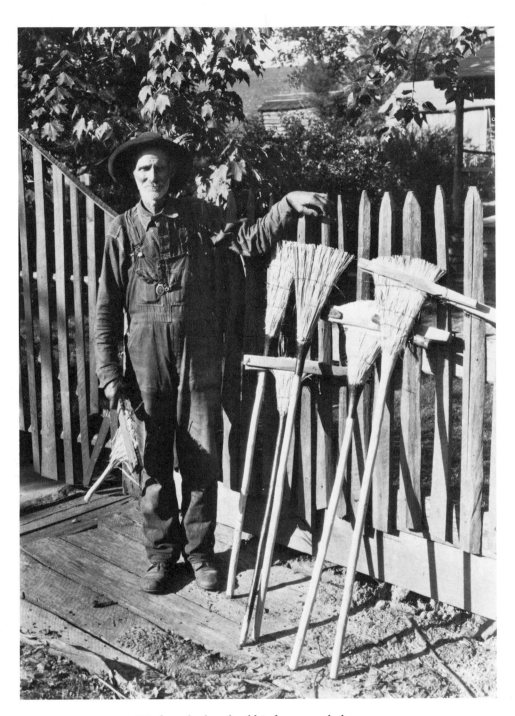

Wash and a batch of his homemade brooms.

Mr. Bohm and I went over to see the Wash Barnes place Friday, October 3, 1924, and Mrs. Barnes was at first as cross as ever. Started to give me fits about "The Lost Cabin" poem Walter Greenough had in The Sunday Star. She said the place wasn't lost, and told Carriani to tell me so. That all the triflin' artists were still painting there. She loved to keep her flower garden in good shape, for when the artists came to paint it and their work was sent over the country she felt she was keeping her garden up for the world. She felt that when a painter came there to work and thought the place was worthy of a picture it was worth asking for and she didn't like some of the painters' freshness.

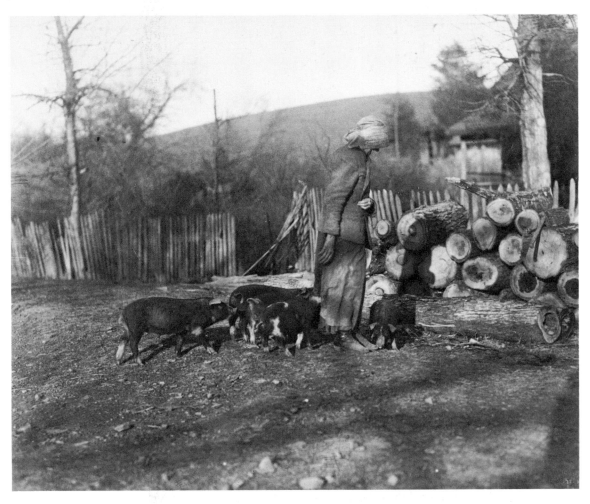

The last photograph of Grandma Barnes, December 23, 1933.

Needless to say, the youth of Brown County
adapted readily to national pop culture. This girl
was photographed at the Old Settlers' Reunion in
1931.

Epilogue

THEY HAVE PASSED AWAY. Chris Brummett died on Christmas Day, 1943, in the house where he was born. His farm is now part of Yellowwood State Forest; the only evidence of the neighborhood is the Brummett family graveyard, where Chris is buried in an unmarked grave. Felix is there too, after ending his days at the county poor farm. His grave is still faithfully tended by the son who was separated from him for life by Felix's divorce in 1918. Oliver and Mary Neal came back to Lanam Ridge to be buried with their parents. Grandma and Wash Barnes are nearby. Ellen and Preston Petro, Alex and Mandy Mullis, and the Bohalls are in Duncan Cemetery. Joe Bohall's farm on May Branch is now part of the Hoosier National Forest, as is the Petro place on Dry Branch. Both Mullis farms have disappeared into Brown County State Park. The Beisels are in Mt. Moriah Cemetery, isolated within Camp Atterbury Military Reservation. Ida Parks's farm was taken by the U.S. Army Corps of Engineers as part of the floodplain for Monroe Reservoir. Ida and Sam Parks and Harry Kelp are in Nashville's Greenlawn Cemetery. Allie Ferguson and Molly Lucas lie in vandalized graves in the neglected Oak Hill Cemetery, near their childhood home. Valentine Penrose, who outlived two widows, is buried with his first wife in New Bellsville. Ed Voland and his wife are buried in Bartholomew County. Frank Hohenberger outlived, or as Allie Ferguson would say, outdied them all, except Harry Kelp. The photographer died on November 15, 1962. Unlike everyone else in this book he does not rest in a country graveyard surrounded by family and neighbors. After 45 years among the Brown County folk he was placed alone in a mausoleum at Crown Hill Cemetery in Indianapolis.

Hohenberger arrived in Nashville expecting to find a sleepy village of amusing and peaceable rustics; he wished to be adopted as a rustic himself. For about fifteen years he tried to create this impression in words and pictures. By the early 1930s his assumptions had gone awry amid the rancorous complexities of small-town life. As Hohenberger learned, rustic folk are always receding. To people in Indianapolis or Chicago, everyone in Brown County was a folk. In Nashville, the folk lived out in the country. Out in the country, they were always in the next township, farther into the woods, deeper into the hills. Eventually the photographer sought his simple souls elsewhere—in the Georgia Sea Islands, the Appalachian Mountains, Nova Scotia, Mexico. Hohenberger never stopped looking for pristine rural characters, although he did stop pretending to be one himself.

The idea that some people qualify as genuine folk while others do not is a

tricky one. Hohenberger first endorsed the idea in order to feel a part of a close community, but by making the folk/nonfolk dichotomy the basis of his popular writings and photography he alienated himself from that community forever. Yet, as a romantic notion, believing in the folk is an effective way to reject the Here and Now in favor of the There and Then.

The geographer John Kirtland Wright coined the term *geosophy:* the study of the way humans imaginatively structure and evaluate the landscape. Geosophically, what happened in "the Hills O' Brown" is clear. To Hohenberger and others from the flatlands, there was no question that south of Helmsburg the country people were different. They lived in an unusual terrain, and their ways of building, farming, cooking, dressing, worshipping, and speaking were unusual. But the artists and tourists mistook a distinction in cultural space for a difference in historical time. The people of Brown County were not very good in their ascribed role as the last of the pioneers. They, at least, knew that they were not lost in the past.

In 1981 over 1,300,000 people visited Brown County State Park. In recent years two large convention centers have been built in Nashville. Recreational enterprises in the county now include ski resorts and commercial music halls, in addition to dozens of antique shops, gift shops, and restaurants. Most visitors get no closer to the inner life of Brown County than eating fried biscuits at the Nashville House or buying a corncob pipe at the Abe Martin Lodge. Yet it is still agreed that there is (or was) something special about the place, that Brown County represents a quality lost in modern times. Ever since the county began to receive favorable reviews by outsiders one hundred years ago, attempts to explain its special quality have contrasted urban life with rural life, usually asserting Brown County's remoteness, unique scenic beauty, social innocence, and indefinable folksy essence.

This last assertion about Brown County seems the most fanciful but may be the most real. It is easy to show that the county is not remote; it is the nearest part of the South to the North. Similar counties, such as Martin County and Crawford County, were not romanticized because they were farther from Indianapolis. Even within Brown county, the Barnes place was popularized as the Lost Cabin not because it was hard to find but because it was conveniently easy to find. And the county's scenery is not unique, as anyone in the hilly, hazy areas of southern Indiana would be happy to point out; the often-painted hills are merely the closest hills to the large flatland cities. Contrary to what city visitors would like to believe, the inhabitants of those hills have always been skilled at factional feuding and speaking out for or against one another.

The elusive folksy essence of life around Nashville may be described as a mode of thought and a related style of self-expression. When Chris Brummett asked who could name the twelve apostles he was stating his preference for

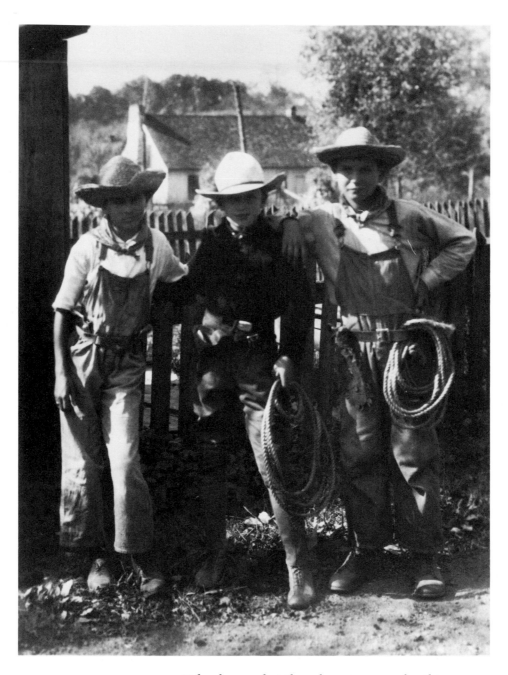

Hohenberger shot these boys in 1924, shortly
after the opening of a movie theater in Nashville.

speaking from memory rather than a printed text, and this preference was not confined to Brown County. Compared to members of the typographic culture in industrialized cities, members of the oral culture in rural areas had a different sense of humor and a different sense of time, which caused them to speak and act in ways that educated people envied.

The subscribers to the *Indianapolis Star* read Hohenberger's columns with a nostalgia for the days before reading and writing were the bases of knowledge. They yearned for what they perceived to be a lost freedom of action and belief. If John Yoder always got his hair cut in the dark of the moon and Mrs. Bohall thought that chiggers had legs on both sides of them, they were enjoying a sense of certainty unavailable to people schooled in the scientific method. And when Allie Ferguson turned back the clock to avoid being late and Scott Moser suspended courtroom business until the end of a game of checkers, they were indulging in a flexibility with time not often allowed to city workers. To say "too old to be forgotten" instead of "too old to be remembered," or "if you don't outdie me" instead of "if you don't outlive me" was to take liberties with both speech and time that were unacceptable in the realm of Standard American English.

Finally, there was something hauntingly familiar but forgotten about the natives' skill with proverbial lore and metaphor. Hohenberger was unusually sensitive to this skill, and even though he never learned it himself, he was sorry that the younger generation in Nashville seemed more eager to imitate Hollywood movie stars than their own grandparents. When Allie Ferguson would say "It's a long lane that has no turning," or when Alex Mullis would say "They barked at the hole but the fox weren't there," they were using a style of expression that was truly old-fashioned. Urbane upper-class people missed it, just as they missed the time to relax on a shady bench, and the ability to tell a good lie.

The 1926 graduating class of Brown County High School.

Nashville seen from the lookout tower at Hilltop Camp, south of town,
in early spring of 1929 or 1930.

NOTES TO PROLOGUE

1. The best source for the early history of Brown County is Charles Blanchard, ed., *Counties of Morgan, Monroe, and Brown, Indiana. Historical and Biographical* (Chicago: F. A. Battey and Co., 1884), even though it was compiled a century ago. In the Prologue I have relied on it for all factual information pertaining to the nineteenth century.

2. U.S. Bureau of Census figures show that the population decreased 6% from 1890 to 1900, 18% from 1900 to 1910, 12% from 1910 to 1920, and 26% from 1920 to 1930. Detailed statistics from the 1925 farm census are given in the article "Census Shows Fewer Brown County Farms," in the *Indianapolis News* of June 13, 1925. This article, as well as others quoted in the Prologue, are in Hohenberger's file of miscellaneous newspaper clippings, included in his papers at the Lilly Library.

3. When the regional art establishment finally realized how passé the Brown County art colony was, it was forgotten with such vehemence that it has never been treated by art historians or contemporary critics, although its influence lives on in popular culture. This ne-glect by scholars is unfortunate because Nashville supported some fine artists whose only fault was being ideologically static. In one of those cultural quirks typical of the United States, most of the artists identified with Brown County were disciples of French Romanticism, while most of their Indianapolis clients were students of German Idealism. It is not possible here to delve into the motivations of the individual artists and patrons, but readers desiring more general background might consult Wanda M. Corn, *The Color of Mood: American Tonalism 1880–1910* (San Francisco: M. H. DeYoung Memorial Museum et al., 1972); Peter Bermingham, *American Art in the Barbizon Mood* (Washington, D.C.: Smithsonian Institution Press, 1975); and Donelson F. Hoopes, *The American Impressionists* (New York: Watson-Guptill Publications, 1972).

4. A Ph.D. dissertation in the Indiana University Library offers more information concerning Lieber and Brown County State Park: Robert Allen Frederick, "Colonel Richard Lieber, Conservationist and Park Builder: The Indiana Years," 1960.

CHECKLIST OF PHOTOGRAPHS

This list gives Hohenberger's own titles and index numbers, and dates for the photographs. In the margin of the large-format negatives he often scratched the date of development, which is usually the same as the date of exposure.

141

KEY TO HOHENBERGER'S DIARY ENTRIES

The numbers below refer to page locations in Hohenberger's diary notes. Four editorial guidelines have been used in preparing these excerpts for publication:

Hohenberger typed his notes. What are construed to be typing errors have been corrected. In a few cases an obscure phrase has been interpreted, if the obscurity might be due to a typing error. Incidental errors in spelling and grammatical agreement have been corrected.

Variant spellings of personal names have been retained. In some cases, for the sake of clarity, an abbreviated name has been given in full.

Where Hohenberger recounted dialogue without quotation marks, none have been inserted. In entries where he introduced quotation marks, more have been added, if needed for consistency, throughout the entry.

Hohenberger often prefaced his entries with an indexical subject heading, such as PHOTOGRAPHY or NATIVES. These headings have been deleted or incorporated into the first sentence of the entry. When a heading has been incorporated, it either appears as the subject or replaces a direct object pronoun.

The intent of these emendations is to make Hohenberger's meaning clearer. It is suggested, however, that scholars wishing to reprint a passage should consult the original typescript in the Lilly Library at Indiana University.

<table>
<tr><td>PAGE</td><td></td><td>PAGE</td><td></td></tr>
<tr><td>32</td><td>61, 254, 293, 297, 298, 298, 300–301</td><td>67</td><td>164, 191, 271, 350, 360, 365</td></tr>
<tr><td></td><td></td><td>68</td><td>372, 403, 404, 406, 408, 408, 410, 426, 458</td></tr>
<tr><td>33</td><td>303, 305, 332</td><td></td><td></td></tr>
<tr><td>34</td><td>401, 466, 514</td><td>76</td><td>226, 259, 298</td></tr>
<tr><td>38</td><td>9</td><td>77</td><td>299, 302, 313, 325, 373</td></tr>
<tr><td>40</td><td>33</td><td>79</td><td>376, 381, 382</td></tr>
<tr><td>41</td><td>169, 200</td><td>80</td><td>390, 399, 401, 415, 424, 475, 501</td></tr>
<tr><td>43</td><td>215, 339, 393</td><td>83</td><td>219, 298, 387</td></tr>
<tr><td>46</td><td>166</td><td>85</td><td>404, 433</td></tr>
<tr><td>47</td><td>173, 179, 196, 199, 200, 205, 205, 219</td><td>86</td><td>436</td></tr>
<tr><td></td><td></td><td>89</td><td>234, 361</td></tr>
<tr><td>49</td><td>220, 221, 222, 222, 231, 237, 239, 246</td><td>91</td><td>361, 362, 363</td></tr>
<tr><td></td><td></td><td>93</td><td>452, 474, 523</td></tr>
<tr><td>50</td><td>263, 284, 292, 294, 305, 307</td><td>99</td><td>315, 388</td></tr>
<tr><td>52</td><td>318, 318</td><td>104</td><td>341</td></tr>
<tr><td>53</td><td>331, 359, 458, 502, 525</td><td>109</td><td>129, 350–351</td></tr>
<tr><td>56</td><td>59, 127, 140, 158</td><td>110</td><td>352, 468, 470, 507</td></tr>
<tr><td>58</td><td>166, 185, 187, 203½, 203½, 204, 204, 206, 222, 241</td><td>116</td><td>284</td></tr>
<tr><td></td><td></td><td>117</td><td>357, 411, 423</td></tr>
<tr><td>59</td><td>252, 254, 262, 274, 302, 305, 305, 334, 339, 364</td><td>118</td><td>475</td></tr>
<tr><td></td><td></td><td>122</td><td>199, 306, 458, 464, 466</td></tr>
<tr><td>61</td><td>436, 461, 473, 488, 495</td><td>128</td><td>45, 93, 234, 295, 351</td></tr>
<tr><td>65</td><td>71, 146, 163</td><td>131</td><td>360</td></tr>
</table>